Ink Drawing
TECHNIQUES

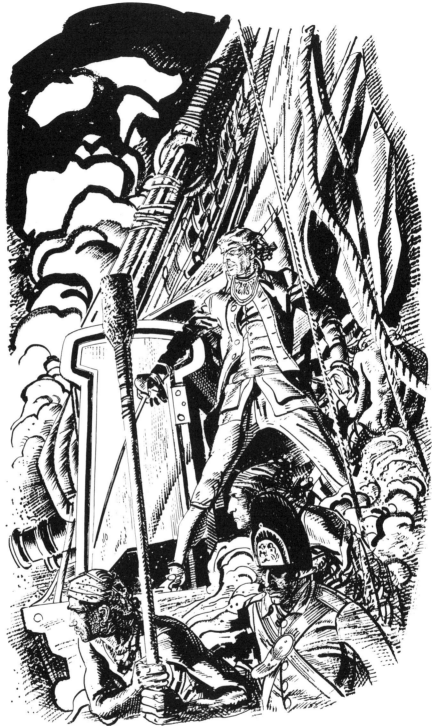

ROBERT FAWCETT
Brush drawing for
Saturday Evening Post

Ink Drawing
TECHNIQUES

BY HENRY C. PITZ

Formerly, Director, Department of Illustration,
Philadelphia Museum College of Art.

Watson-Guptill Publications
NEW YORK

To Aunts May, Hettie, and Clara

First published 1957 in the United States by Watson-Guptill Publications,
a division of Billboard Publications, Inc.,
1515 Broadway, New York, N.Y. 10036

Library of Congress Catalog Card Number: 56-12495
ISBN 0-8230-2550-0

Manufactured in the U.S.A.

First Printing, 1957
Second Printing, 1964
Third Printing, 1968
Fourth Printing, 1970
Fifth Printing, 1972
Sixth Printing, 1974
Seventh Printing, 1976
Eighth Printing, 1977
Ninth Printing, 1979

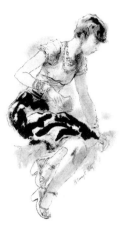

Preface

THIS BOOK IS NOT A HISTORY but a manual. It is not the story of ink techniques throughout the history of art, although it has been difficult to resist the temptation to explore and disclose the fascinating network of paths the medium has followed since the first inks, brushes and pens were discovered to be loved and expressive tools. The bursting treasury of ink drawings that has come down to us is rich with masterpieces, but we are able only to refer to them in passing. This is an introduction to a group of techniques — a guide for those who hope to become able performers in a chosen medium. Its hope is to be precise and definite without becoming pedantic and, at the same time, offer wide-open incentive for individual development without relying entirely on generalities.

The book is not a one-man affair — many have helped in small and big ways. It stems, in part, from many happy casual conversations with old friends who have loved the medium — Edward Warwick, Norman Kent, Lyle Justis, Albert Gold, William Emerton Heitland, Arthur Guptill and William Blood. My youthful conversations with Joseph Pennell have certainly played a part. Then there are the years of teaching and the hundreds of students who were unaware that they were educating me.

Many pen draughtsmen have been kind and helpful — Fritz Eichenberg, Robert Fawcett, Frank Hoar, Lynd Ward, Jacob Landau, Ronald Searle, Joseph and Beth Krush, Albert Dorne, Edward Bawden, Franklin McMahon, Edward Smith

and Isa Barnett are a few. Many publishers and editors have offered suggestions and lent drawings. I am particularly grateful to Diana Klemin, C. O. Woodbury, John Pellew, George Macy, Helen Macy and Max Stein of the Limited Editions Club, Paul Darrow, Louise Bonino, and Vito Verlotta. The manufacturers of artist's materials have been almost uniformly helpful and I owe especial gratitude to Fred Weber. I have drawn upon his encyclopedic knowledge of art materials many times.

I am indebted to Graham Reynolds, Deputy Keeper at the Victoria and Albert Museum, Percy Bradshaw of London, and Edward Croft Murray of the British Museum. Edward M. Allen and Norman Kent have read and checked the manuscript and lastly my wife has not only read and typed it but has patiently revised my erratic spelling.

EDWARD BAWDEN

Drawing for
Fortnum & Mason

Contents

INK DRAWING TECHNIQUES

FRANKLIN MCMAHON

Drawing for
Marshall Field & *Co.*

HENRY C. PITZ
Illustration for Hansel and Gretel
Limited Editions Club

EDWARD SMITH

1: Pen and Ink — Its Character

EACH OF THE MEDIA that the artist uses has a separate character; that of pen and ink is more positive than most. It does not lend itself readily to tentative or equivocal pictorial statements; it is clean, sparkling, and downright. It is an ancient medium but its expressive powers have been rediscovered by every age. Our own age has found it admirably fitted for the dual modern impulses of mechanistic statement and wide ranging experimentation. Many new technical methods have been explored and the resources of the medium have been exploited as never before. Pen and ink has become a vital modern method of expression.

It has certain outstanding characteristics. One of the most important is its *directness*. The first touch of the pen to paper makes a mark that has a look of finality. The ink line can be erased but only with great difficulty; it can be modified or changed but not with ease. Fumbling and indecision reveal themselves at once and seldom can be concealed by the later developments of a picture. So the pen technician finds that his approach must be bold and confident, but boldness and confidence are spurious virtues if not founded upon knowledge and a clear conception of graphic objectives. In short, the medium makes serious demands on the artist; it calls to his strength and offers little comfort to his weaknesses.

While the artist is molding the medium he also discovers that it is molding him. This is why many hesitate and turn away from it; they fear the challenge of its forthrightness. But those who succumb to its appeal and practice it, find that it fortifies their ability to make definite graphic decisions and to be positive in their delineations of form. The true artist welcomes a medium that will challenge him and induce him to give of his best.

JACOB LANDAU
Drawing for
Little Lower than the Angels
Union of American Hebrew Congregations

VENVS QVID
OMNES ·
VENIAT

JOSEPH C. COLL
Pen and brush drawing

13

A second important characteristic of the medium is the limited palette of tones that can be readily produced. Since a pen-and-ink tone is brought into being by ink lines or shapes placed at varying distances from each other, or overlapping each other, the number of possible gray tones between the extremes of black and white is limited. It is impossible to blend imperceptibly one tone into another as is the case with the paint media or charcoal, for example. At best, it is feasible to use no more than five or six gray tones between black and white and fewer are often more advantageous. The pen artist must become accustomed to simple and emphatic tonal relationships. In fact, he creates a new set of relationships.

These relationships, although a limitation, are one of the special beauties of the medium. The artist learns that from the multitudinous tones of nature he must select and simplify, to push tones toward one or the other end of the scale for purposes of emphasis, to eliminate the nonessentials, to become a pictorial dramatist. He discovers that he has chosen a medium which does not lend itself to a copy of nature, but encourages interpretation. And it will also encourage him to suggest rather than report in detail.

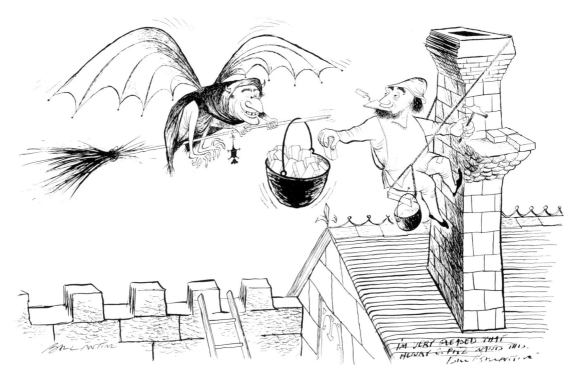

WILLIAM BALLANTINE
Illustration for True magazine

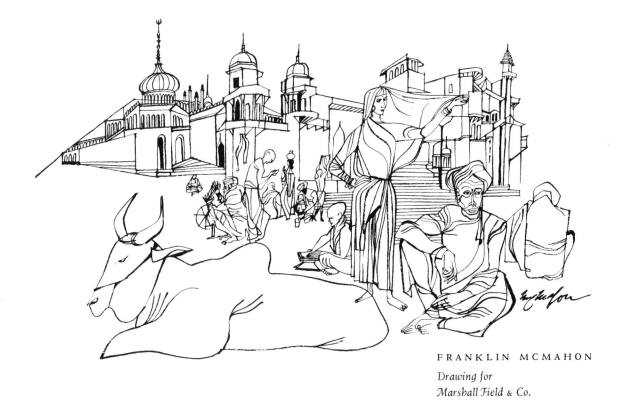

The need for simple tonal schemes links with another characteristic of the medium; the frequent use of the outline to define or suggest the boundaries of forms. Wherever two forms of approximately the same tone impinge upon each other, the use of the outline to separate the shapes becomes a natural expedient. It is a convention, but a very beautiful one that springs from the nature of the medium. In the hands of a real artist the outline becomes an infinitely varied and intensely expressive thing.

Because of these characteristics, pen and ink has a dialect of its own. It draws its strength from its simple materials and the straightforward use of them. Its limitations are not a handicap but a glory. The more one studies and the more one practices, the more one becomes aware of its great range and versatility. It is a medium for both the dreamer and the factualist. It can talk in terms of sensitive, lacelike arabesques or crashing, brute-like blacks. It can be made to speak the language of fantasy, of clear, unadorned mechanistic precision or high-pitched drama.

The modern movement in art with its feverish craving for experimentation has laid hands upon it and freed it from many prim and unintelligent taboos. Its potential of expression is now greater than a generation or two ago. We still call the medium pen and ink, but this is for convenience only. It is scarcely an accurate term in an age when we use the brush almost as much as the pen and at times resort to blunt twigs, small wads of cloth, smudged fingers or other unorthodox instruments.

For almost a century, pen and ink has preserved its vitality largely because of the constantly increasing use of illustration and because one of the common and cheapest methods of mechanical reproduction, the line-cut, needed the sharp black delineation of the pen line. Looking into the foreseeable future one can discover no signs of diminution in the use of line illustration, in fact all signs point to its expansion. But now in addition the medium, often in conjunction with one or more other media, is used as a method of art expression in its own right.

Whatever the reasons for studying the medium may be — as a means of livelihood, of self-expression or for sheer pleasure — that study should be impelled by a sense of attraction toward it. It is not a miracle-working medium — no medium is. But it can have rich rewards for those who care and try. No medium reveals its deepest secrets except to those who love it.

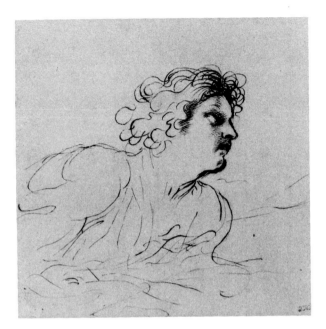

2: Methods of Study

ANY SUCCESSFUL TEACHER knows that he must have a plan for imparting his subject but that any plan should be subject to modifications that will fit the varying requirements of individual students. The plan of this book is very simple. First, to convey a well-rounded picture of the subject, measuring its possibilities and engendering enthusiasm; second, to describe the materials and indicate their use; and third, to suggest a series of practice problems that pass from the simple and easy toward the more involved and difficult. But the plan is disclosed by suggestion rather than dictation. After the first few beginning problems there is no long listing of so-called *step-by-step* procedures; only the general path is pointed out with suggestions of practices from which each reader will make his own choice.

The making of one's own choices should show itself early in the development of the creative artist. His stature as an artist depends largely upon his

powers of selection and rejection. So the way has been left open for choice among a number of possibilities and each purposeful choice will make for confidence and growth. But freedom of choice works both ways; it can become a device for the evasion of difficulties and a following of the path of least resistance.

Difficulties are part of every artist's development and they must be met and mastered. Pen and ink is not an easy medium but the challenge of its difficulties can be a welcome spur to any talent that possesses vitality.

If the mastering of ink technique had to be summed up in a single phrase, it might be done fairly successfully by saying, "incessant practice." Incessant practice is a necessity. It should be a joy and a release, a natural functioning of the growing artist. But it has to be practice informed with purpose, enthusiasm, and intelligence. It should be a seeking and searching practice; eager to try its hand at new problems; willing to seek for new solutions to old problems.

If this book can suggest that each problem solved prepares the way for a score of new opportunities, that doors open on every side as one observes and works, and that the daily practice of picture making, on no matter how humble a scale, is its own reward, it will have served its purpose.

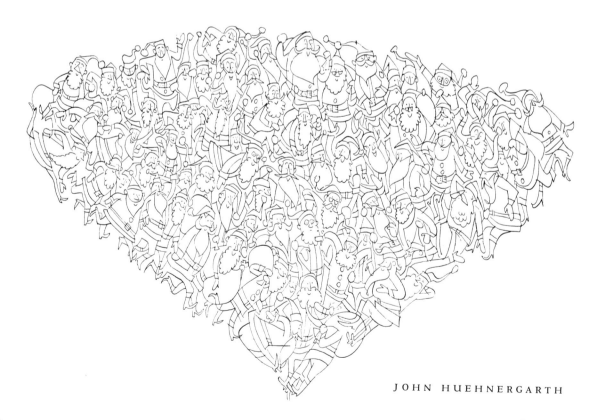

JOHN HUEHNERGARTH

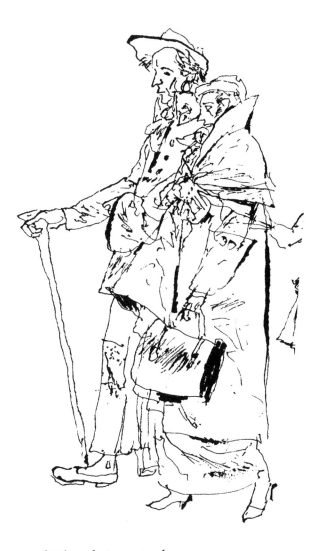

LYLE JUSTIS

The student will soon discover that the practice of ink techniques is always entwined with the problem of drawing. As soon as one attempts to describe a form or glorify a shape in ink, one must draw — so one would be ill advised to attempt the ink techniques without some ability as a draughtsman. Granted that ability, the two problems can be tackled together, one assisting the other. After all, ink rendering is just one of the many drawing techniques.

There are many ways by which the young artist may feed his interest and sustain his enthusiasm. One is by pouring over the work of ink draughtsmen present and past. Some students will have access to museums or collections of original works and often, in the case of drawings, there are many not on display that may be taken from the cabinets and studied by application to a curator. The next best thing is the study of reproductions. The reproduction of master drawings is now widespread and most good libraries have small or large collections of such books or individual prints. The student should acquire as many as he can afford for his own library. Some of these volumes are very expensive, others are moderate in price, and often bargains are available for the watchful through the stores and mail-order houses that deal in publisher's remainders.

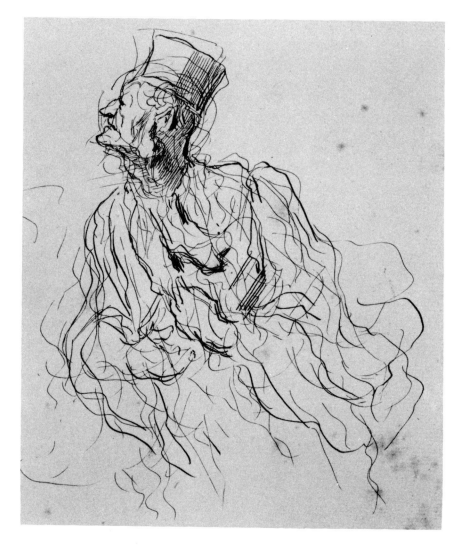

HONORE DAUMIER
Pen drawing
Victoria and Albert Museum

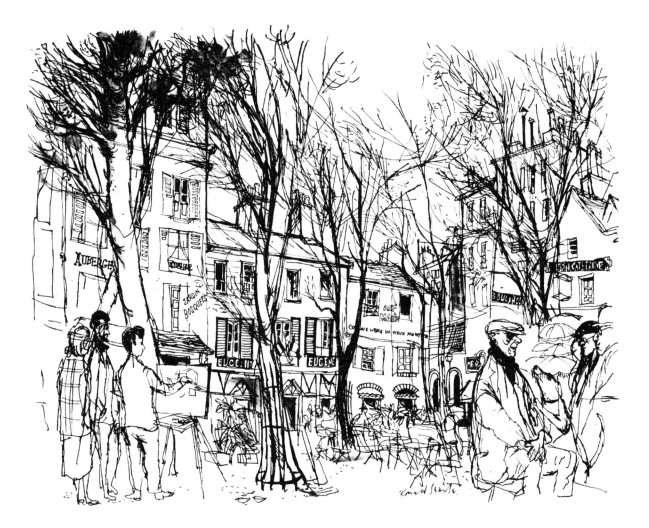

RONALD SEARLE
From Paris Sketches
Sylvan Press

Another source of material is the current magazines, newspapers, and advertising pieces. These contain many examples of contemporary ink artists; a large, gifted and flourishing company, with which the student should become acquainted. The clippings should be kept in folders or large envelopes and when the collection becomes large, sorted and classified according to some understandable system.

It is an advantage, of course, to study under a good instructor. The help that an experienced teacher can impart, plus the impetus that association with other striving students can give is immeasurable. If a student must work by himself, it will help if he can ally himself with others moving toward the same goal. Enthusiasm is communicable. It is good to know that others are traveling the same road. Membership is often available in artist organizations of various kinds and the regular reading of one or more art magazines can be very helpful.

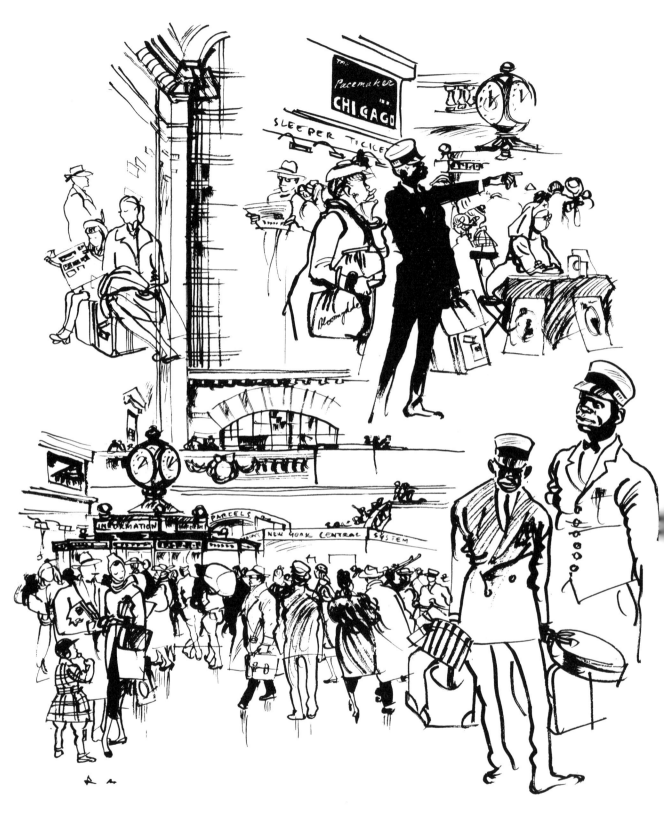

FRANCIS MARSHALL

Drawing from
An Englishman Looks at New York
G. B. Publications, Ltd.

One of the most rewarding efforts is the constant use of a sketchbook and fountain pen. Intervals of even two or three minutes at a time can be used in this way. Anything that confronts one can be drawn. One should not wait for a set composition or something that seems of particular interest. *Anything* can be drawn and turned into a rewarding experience. Drawing the most commonplace things may open one's eyes to untold possibilities. If this plan is persisted in, as the sketchbooks are filled, one by one, a command over both technique and drawing will develop simultaneously. This method is as valid for the seasoned artist as the merest beginner. It will continue to bear fruit all through a long lifetime.

HENRY C. PITZ
Fountain pen drawing

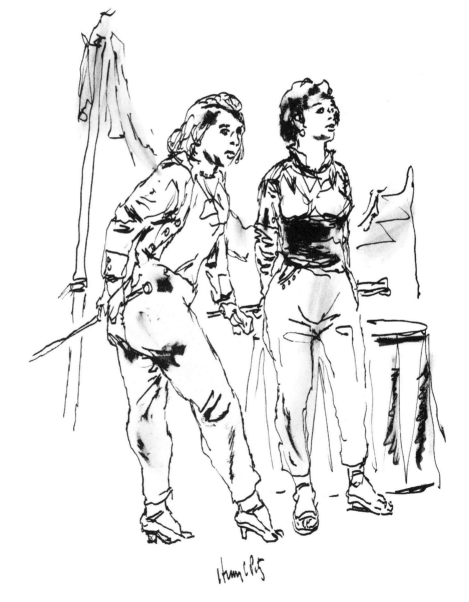

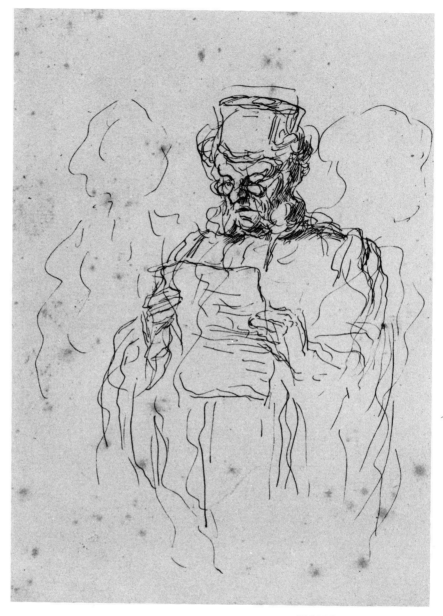

HONORE DAUMIER
Victoria and Albert Museum

3: *Materials*

A MASTERPIECE can be accomplished with a bottle of ink, a pen, and a scrap of paper. So few and simple can be the materials of pen and ink. Many other materials may be added to them, but these are the essentials and let us talk about them first.

The ink most used by pen artists is a waterproof india ink. There are many good brands available. Two of the most widely used by artists are Higgins American India Ink and Pelikan Drawing Ink. Other excellent inks are made by Carter, Craftint, F. Weber Co., M. Grumbacher, Speedball, Artbrown, and Winsor and Newton. For those who work for line reproduction and need an intense black, Higgins Super Black, Artone Extra Dense Black, and Craftint "66" Jet Black are recommended. And for those who must work on vinylite or acetate overlays Grumbacher makes a special ink concentrate which adheres and makes a strong black. Waterproof inks contain a shellac binder so that, once dry, they will not smudge and watercolor or other inks may be washed over them with impunity.

Sometimes a waterproof type of ink is not desirable when an artist wishes to modify and model a dried ink line with a moistened finger or brush. Many manufacturers make nonwaterproof inks, but ordinary writing inks are often suitable for this purpose. Chinese ink in stick form is not in great demand today but when used with a brush it has a very special quality of its own. The stick is rubbed down with water in a small bowl or piece of slate. Any ink not used should be thrown away as the dried ink flakes and becomes useless. In this country stick ink is made by Grumbacher.

Inks are made in a wide variety of colors and in two types, transparent and "pigment" or opaque. The transparent inks are mostly brilliant in hue but many of them fade rapidly. Great depth and richness of color can be obtained by painting one color over another. Many layers may be superimposed with little danger of muddiness. Good colored inks are made by Higgins, Pelikan, Craftint, and Grumbacher. The "pigment" inks are useful for flat poster effects or color separations. F. Weber has an excellent series of pigment colors.

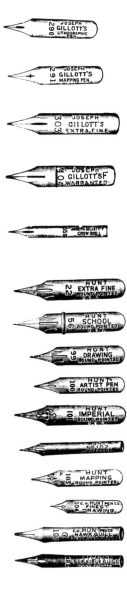

*Various drawing
pen points*

There are a bewildering number of pens available to the artist. There are two American brands, Esterbrook and Hunt, and one English, Gillott, readily obtainable in most art-supply stores. Another fine English manufacturer, Brandauer and Co., is not so well known in this country but their pens are excellent. Possibly as time goes on, some pen artists feel an inclination to try all available pens but it would be folly to begin that way. All pen points mentioned are good — capable of rendering excellent drawings but they are passive instruments. It is the controlling head and hand that make for accomplishment. It is only too easy to persuade oneself that the magic resides in the instrument.

One might begin with all-around points such as Gillott 404, Esterbrook 358, Hunt 56, and Spencerian 98. These all give a reasonably fine line and are sturdy and flexible. They will not give the beginner too much encouragement toward the fussy and finicky, which is the earliest pitfall that lies in wait for him. Another good all purpose group, very slightly finer, would be Gillott 303, Hunt 22, Esterbrook 357, and Brandauer 303.

Below is a chart which arranges the pen points of different makers on a comparative basis. This should help the student establish some order in his exploration of his chosen instrument. In general, the point numbers read downwards from very fine to medium fine. But these may all be called fine points and the student will soon discover that there seems to be little difference in weight of line between many of them.

ARTISTS' PEN COMPARISON CHART

Gillott	Brandauer	Hunt	Esterbrook
170	0131	99	356
290	515	100	355
291	517	103	354
303	303	22	357
404	134	56	358

Crow-quill Points

659	214	102	62

This chart by no means lists all the available points but it contains those most likely to be used and should provide ample selection for all save those determined to try everything. Gillott and Hunt sell cards containing a selection of points — these are an excellent start for the student.

For sketching with ink, fountain pens avoid the messiness of carrying about

fragile pen points and spillable bottles of ink, but no fountain pen point has the responsiveness of the points we have been discussing. Still, delicacy of response can develop into a trap and a more reluctant instrument will correct any inclination to fussiness.

Ordinary fountain pens can be used, of course, and while the usual blue writing ink is not too appealing, brown and blackish inks are available. Drawing inks should not be used in the ordinary fountain pen as they clog and refuse to flow. There are a number of pens made for drawing inks. Waterman pens are excellent, although now difficult to obtain and an English import is the Osmiroid "65" for which a number of different sized nib-units may be purchased. A very new fountain pen is the Grafika, for which is claimed 700 feet of line without refilling.

Any ordinary holder may be used for drawing pens, except the crow-quill type, for which a special holder is supplied. The crow-quill holder is usually narrow and, since an artist should not have a cramped and tense feeling when holding his pen, it is often wise to force a pierced cork down the shaft or wrap it to a suitable thickness with adhesive tape. Many artists find a holder with a rubber or cork grip most satisfactory.

Pens should be wiped clean after using with a soft rag as the dried ink makes a crusty deposit. If this is left in the pen it should be scraped off with a knife before using or dipped in ink solvent.

Many kinds of brushes have been used in the ink techniques but the type most consistently favored is the red sable because of its spring, its responsiveness, and its ability to render a hairline or broad sweep in one stroke. The better grade of watercolor brushes, usually in the small and medium sizes is favored. Fine brushes made by Delta, F. Weber, Grumbacher, and Winsor and Newton are easily obtainable. Another form of red sable, which is a favorite for broad stroking, is the lettering brush with square ends. Camel hair and bristle brushes are also in use but usually for special effects.

Paper is the foundation of a drawing and of the greatest importance. There are innumerable suitable papers and the artist must do a reasonable amount of experimenting to find the kinds most suitable to his temperament. A pure white stock is best for most work, tough enough not to be lacerated by a pen stroke and well enough sized so that the ink line does not spread. There are

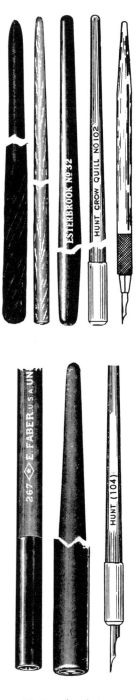

Various drawing pen holders

27

many kinds of paper and boards made especially for the pen artist but there are also many papers made for other purposes that will do excellently. Bond papers are a favorite of many artists, and most writing paper stock is suitable. In addition, there are many of the book papers and some of the finer grades of wrapping paper.

But the tried and true surfaces are those which have been made for the artist and used by him over the years. There are famous makes of paper such as Whatman, Canson, D'Arches, Fabriano, Millbourne, Arnold, and R. W. S. These are all foreign brands; in this country the largest manufacturer of artist papers is Strathmore.

Many manufacturers prepare their papers in three surfaces, smooth (hot-pressed), medium (cold-pressed), and rough (cold-pressed). The smooth surfaces permit the pen to glide easily and are best for facile and slick technique and for fine copperplate detail. The medium surface with its slight tooth is the most popular. It breaks up the line just enough to impart character. The rough surfaces are good for large scale work done with sweep and spontaneity.

HENRY C. PITZ
*Brush drawing on
smooth-finish board*

HENRY C. PITZ
Pen drawing on Arches paper

LYLE JUSTIS
*Pen and brush drawing
on Canson paper*

Papers also come in varying weights and thicknesses. The thin or single-thickness papers (and they are cheaper) may be used as they are for smaller drawings but large sheets will not lie smoothly unless stretched. The sheet should be moistened with a soft sponge (not soaked) and placed on a drawing board, working side up. Wide strips of gummed tape should be fastened to the edges. The paper should be pressed gently outwards with the fingers, especially from the corners. After this stretching the gummed strips should be pressed tightly to the board and the paper allowed to dry naturally. If the stretching has been adequate the paper will dry to the tautness of a drumhead. Overstretching or accelerated drying will sometimes cause the paper to split. Many papers come in two, three or more ply thicknesses particularly the so-called *bristol boards* or smooth surfaced (hot-pressed) papers. These multiple-ply boards and papers permit very deep erasures.

29

Many artists prefer the so-called *illustration boards* which are drawing papers mounted upon a heavy cardboard backing. There are many excellent brands available. Whatman's is one of the best. Strathmore comes in many thicknesses and surfaces and both sides of the cardboard mount are covered. Excellent boards are Superior, Crown, Bainbridge, and Majestic Watercolor Board. Hurlock and Bros. make boards of several qualities as do some of the other manufacturers. In the main, quality is in direct relation to the price. The economical boards are usually good for direct manipulation but they cannot be expected to stand the erasures and wear and tear of the finer surfaces, nor will a machine-made paper have the quality touch of the handmade, all-rag kind.

ALBERT DORNE
Pen and brush on hot-pressed
illustration board
American Heritage Foundation

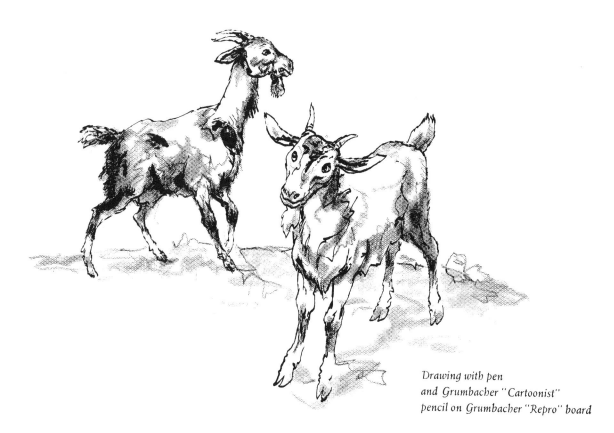

*Drawing with pen
and Grumbacher "Cartoonist"
pencil on Grumbacher "Repro" board*

There are also a number of boards with specially applied surfaces such as the chalk coated scratchboards and stippled surfaces made by the Chas. J. Ross Company; M. Grumbacher has a line of "Repro" and Coquille boards for commercial artists. And every artist will have need for a good quality tracing paper in roll or tablet form for practice and transfer purposes.

The mark of the pencil is seldom seen in the completed pen drawing and yet the pencil usually lays the foundation and an inferior tool is a handicap. Drawing pencils are usually graded from 9H (very hard) through HB (medium) to 6B (very soft). Most pen artists seem to prefer HB to 3B grades. The very soft degrees are difficult to keep pointed and their lines smudge easily. The very hard grades are preferred by those who are concerned with mechanical accuracy or meticulous detail. Excellent brands are American, "Venus"; Eagle, "Turquoise"; Wolff, "Royal Sovereign"; Dixon, "Eldorado"; Ebehard Faber, "Microtomic"; and Hardtmuth, "Koh-I-Noor."

The lithographic crayon is sometimes used in an ink drawing for its speckles of black have an affinity for the inked line. It is graded from No. 0 (extra soft) to No. 5 (copal or very hard) and comes in both pencil and stick form.

The pen artist usually wishes to clean his drawing after all parts are inked in. In order not to dull the pen lines, soft erasers and gentle rubbings are necessary. Good erasers are Faber's, Dixon's Pixit, F. Weber Company's kneaded eraser, and Artgum. For corrections a hard typewriter eraser may be used, or a razor blade or the spade-pointed scratch knives which fit into a pen holder.

A good drawing board is important. They come in various sizes and the artist should pick the size that fits his work. It would be well to have several — at least one small one and one large one. The type with battens is less likely to warp. Tempered masonite cut in suitable sizes is excellent. If exact work is to be done, a steel edge should be fastened to one edge of the board and a steel T square used in conjunction with it. Almost all artists will have need, at times, for some mechanical instruments — triangles, compass, dividers, springbow and ruling pens. Thumbtacks (the type with solid heads) are a necessity, as are razor blades or X'Acto knives, for trimming. A jar or tube of opaque white for correcting pen mistakes is also helpful. Craftint Superwhite 37, Artone White, and Talens Hi-White watercolor are excellent.

The artist of today is offered a bewildering wealth of materials but he should not feel obliged to try everything at once. Excessive experimentation is almost always an indication of evasion, of a pathetic illusion that the miracle resides in materials. The miracles, if they come, will spring from human brains and fingers and be coaxed and developed by incessant practice. After all, the choice of materials is a personal thing — one artist accomplishes wonders with a material that another equally accomplished man scorns.

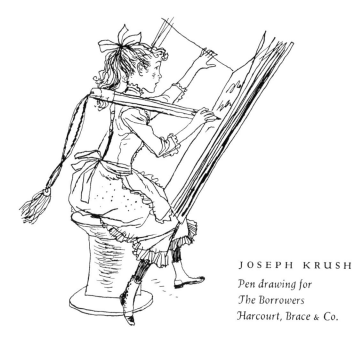

JOSEPH KRUSH

Pen drawing for
The Borrowers
Harcourt, Brace & Co.

4: *Where and How to Work*

AFTER A SUPPLY OF MATERIALS has been assembled, the next step is to put it to use. The pen artist is fortunate that his materials are few and relatively inexpensive and that his work does not demand a great deal of elbow room. A private space that is all one's own is more important than size or superfine equipment.

It should be well lighted both by day and night. This means one clear window, at least, facing north for steady light if possible or, if it is a window that admits the sun, some shield or diffuser of the direct sunlight is necessary. At night, one naked electric bulb will do in a pinch, but a shaded and adjustable one is infinitely better and best is an adjustable fluorescent fixture such as can be bought in most artists' supply stores. Light is very important. The glare of too much light beating upon white paper is as bad as too little. For the usual right-handed artist the light should come from the left and from slightly behind.

If the budget permits, there should be a drawing table. They come in a variety of styles and sizes. Art supply dealers either have them on display or can show catalog pictures. Since the pen artist seldom makes very large pictures a big drawing table is not a necessity. Some of the smaller sizes come with a central metal support, the larger sizes have two or four legs. Some tables come equipped with a ledge at the top or side for holding ink bottles and pens. If there is no provision for this, a small table or cabinet placed to the right of the drawing table is a necessity. Ink bottles are easily tipped so a secure place must be found for them and a special holder with a wide base, such as those sold by Higgins and Grumbacher, is often advisable. If one can afford them there are very handsome and elaborate combination tables and cabinets available. If one must cut equipment down to a minimum a drawing board tilted against an ordinary table or chair will do very well.

Three ways of fastening ink bottles so that they are not easily spilled

*Two types of ink bottleholders
made by the Higgins Ink Co.*

Wall cabinets, closets, and shelves would be very handy for holding T squares, triangles, and all kinds of supplies as well as sketches, books, and clippings. As time goes on materials and accessories are bound to accumulate and a place must be found for them. The interested artist will certainly collect clippings of the work of other pen artists, books on anatomy, techniques, reproduction, and other matters pertaining to his medium. In addition to these, there should be clippings culled from magazines, books, newspapers, and advertising matter relating to the possible subject matter of his picture — sports, buildings, machines, trees, costumes, ships, and whatever may interest him.

A few fine examples of pen work, tacked above the drawing table and changed from time to time, may act as an incentive to put forth one's best efforts. In fact, the purpose of a room of one's own is not only to shut out the world so that one may concentrate, but to create a special atmosphere — an atmosphere that tends to encourage work and creation. It should be both pleasant and stimulating and take on the character of the occupant. No one can blueprint that kind of surroundings — they must be assembled by the individual. A studio takes on the imprint of its occupant. If it is used as a place to dream, plan, work and strive, it will, in time, induce these very qualities in one, even when one enters with one's spirits low. A studio can be furnished even with intangible things.

JOSEPH KRUSH

Drawing for
The Ponder Heart
Harcourt, Brace & Co.

5: Line

A PEN DRAWING may be a very elaborate creation but in one sense, at least, it is just an organization of black lines and other marks. The line is the natural mark of both pen and brush and, as a thing in itself, it is important enough to be isolated and analyzed.

It is not putting the cart before the horse, nor hampering any incipient individuality in the novice, to have him examine the work of many different pen artists before he becomes too involved in practice. It would be ideal to examine only original drawings but that is difficult. Good reproductions serve very well, however, particularly with a magnifying glass at hand. The individual lines should be studied and compared with each other. It is soon obvious that a great deal of individuality and expression can be packed into a single pen stroke. Some lines flicker and quiver, some race and bounce, still others move weightily and mightily. One artist's line is tentative and searching, another's is confident and assertive. All human qualities can be discovered in the ink line. The importance of this scrutiny is simply this, to allow the student to become aware of the protean character of the ink line — that it is versatile, pliable and expressive; that it can speak in many moods and accents; that it is flexible and resourceful. In short, when he picks up the pen himself, the student should have the feeling that the instrument he holds is capable of eloquence.

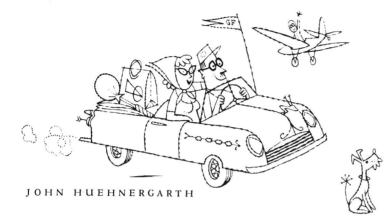

JOHN HUEHNERGARTH

RONALD SEARLE

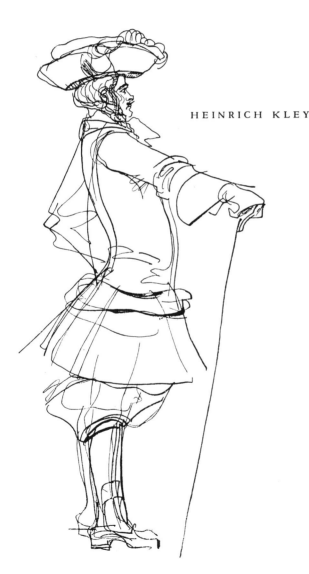

HEINRICH KLEY

The five drawings on these pages give some idea of the variety of expression that resides in line alone. All are examples of what may be called free line but they range from the sophisticated naiveté of Huenhergarth, through the controlled exuberance of Kley, the lively character probing of Searle, the rambling, consciously young line of Suba to the opulent ease of D'Ache. The book is filled with many other examples, — a few that might be scrutinized at this point are on pages 15, 19, 29, 31, 60, 83, 87, 88, 107, 129, 131, and 136.

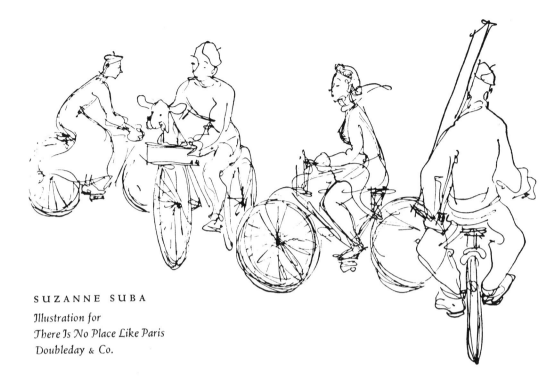

SUZANNE SUBA

Illustration for
There Is No Place Like Paris
Doubleday & Co.

CARAN D'ACHE
Collection of the author

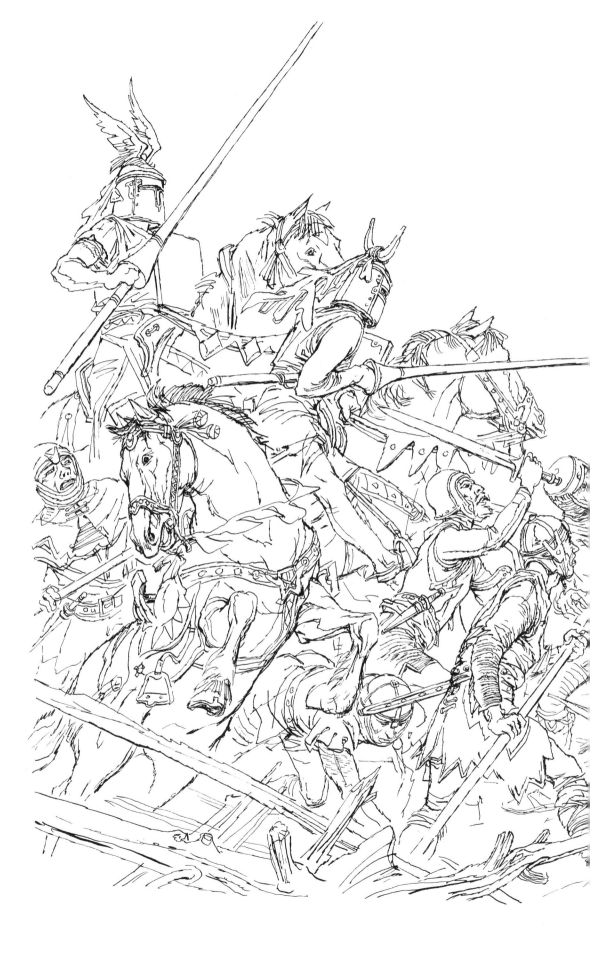

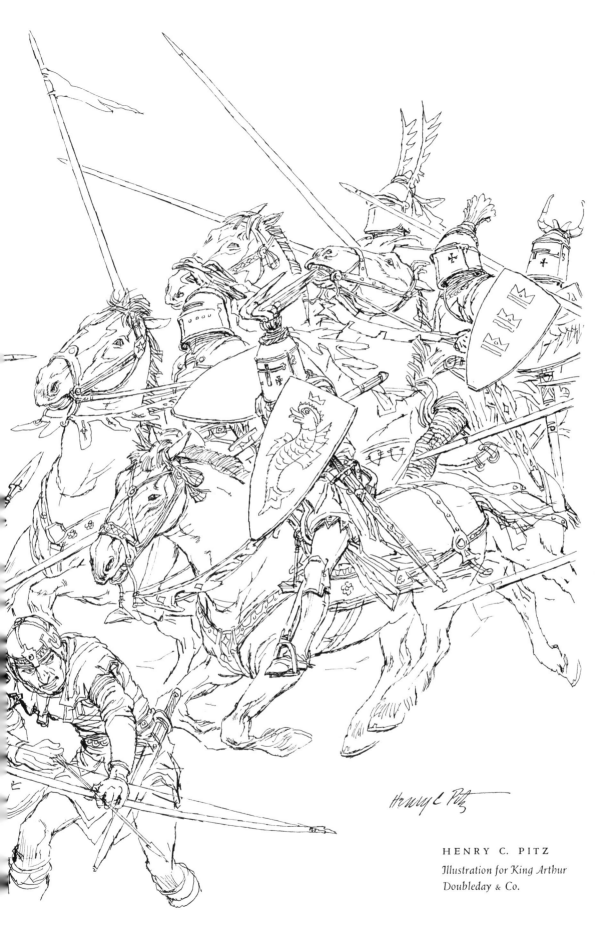

HENRY C. PITZ

Illustration for King Arthur
Doubleday & Co.

The first step is to discover for oneself what the pen will do and then to try to control it. Neither of these admirable things will be discovered at once — control particularly, comes only with long effort and persistence.

First, the necessary materials should be provided — pens, india ink, some sheets of bristol board or smooth paper (it is better to practice first on smooth stock before moving on to a textured surface), thumbtacks, and drawing board. If thin paper is used it should be backed by a pad of other smooth paper or a sheet of bristol board.

It is important to sit naturally and comfortably. A table or other suitable support should permit the drawing board to be tilted at will, so that the drawing is under the eye; that is, viewed at right-angles and not so that the drawing is seen in a foreshortened position. The hand should be able to move over the surface without strain or cramping. The light should be right — best if it comes over the left shoulder. It should be ample but not glaring. Direct sunlight should not fall on the drawing — it makes delineation difficult and is a great strain on the eyes. Good eyesight is too important to the artist to be trifled with.

Various pen marks

The ink bottle will be placed at the right (for right-handed artists), not too close to the table's edge or, better still, on a small table which will also hold pens, pencils, and other accessories. Since ink bottles are easily tipped, it is often wise to place them in a rubber or aluminum holder, such as those provided by the Higgins Ink Co. Sometimes new pens are slightly oily, resisting the ink. A little saliva or gentle rubbing with a rag touched with soap will cure this.

The first thing to discover is what kinds of marks a pen can make. That means trying everything, even if it does ruin a few pen points. Every degree of pressure up to the breaking point should be tried. Every direction of line should be tried and every kind of line — straight, curved, jagged, writhing, staccato. At once it becomes apparent that the pen moves more readily for some strokes than others. It is likely to trip, catch, and spatter when turning sharp corners but this is one of the limitations of the instrument and must be reckoned

with. Incidentally, probably the best pen point for making strokes in any direction is the Gillott Tit-Quill.

This free-for-all doodling is not aimless. It is the quickest way of becoming acquainted with the pen, becoming aware of its power and idiosyncracies, experiencing the feel of it. It should discourage stiffness and the first tense awkwardness, and induce a feeling of a oneness with one's tool.

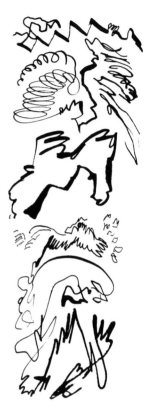

But carefree and planless doodling is not enough. Control must be acquired, so that the hand will reproduce what the mind dictates. This will not come at once but we can begin immediately.

A sheet of smooth paper or bristol board should be laid out in two-inch squares. A medium pen point, such as Gillott 303 or Hunt 22 should be selected and holding it in the orthodox manner, some of the squares should be covered with straight, parallel lines. The pressure on the pen should be normal and no pencil guide lines should be used. Although these are *straight* lines do not expect to duplicate those done with a ruler and ruling pen. It isn't possible and, moreover, is not desirable for freehand work, but at the same time a reasonable amount of accuracy must be striven for in the interests of control. This is careful work and you will probably instinctively pivot on the outside heel of your hand, getting the motion from the wrist. Sets of lines should be drawn in all directions, horizontally, vertically, and diagonally. Eventually your technique may be very remote from this sort of thing, but at the moment we are teaching the hand control by giving it a semimechanical formula to obey.

Just the act of drawing lines, teaches one many little but important things — not to work with a dripping pen, that it is well to scrape off surplus ink on the neck of the bottle; not to work too long until the line turns gray from lack of ink; that too slow a line often defeats the purpose — a faster line is likely to be truer, once confidence is established. Sometimes the pen is grasped too tightly and too close to the nib — try to relax and hold it more naturally. Many lessons are learned more quickly by doing than by reading about them.

On another sheet try a new series of lines. These should be drawn more rapidly and freely. They should be drawn in all directions. You will discover (if you are right-handed) that the most natural line runs diagonally from upper right to lower left and will curve a bit, following the natural arc of the wrist sweep. This is the "northeast" line that is prevalent in the work of so many pen artists. You will notice too, that when a number of such lines are drawn rapidly, there is a tendency for "hooks" to develop at the end of the stroke, where the pen is lifted for the next down stroke. And already, in your own work, you will be aware of the difference in character between the seriousness of the first sheet of lines and the more lively character of the second. Each type of line can be and is used in professional work.

A third group of lines should be attempted utilizing curves. Draw approximate ovals and circles; each in two strokes, one curving away from you, one toward you. Natural limitations will again assert themselves; it is almost always easier to draw curves rounding away from you than toward you.

A fourth practice group should utilize the modulated line. Begin with a light stroke, increasing the pressure and broadening the line; then begin with pressure and let it diminish. Finally, try several modulations in one stroke. These are strokes you will be using constantly in your later professional work.

These beginning problems are frankly finger exercises. In themselves they could make a pen draughtsman of no one, but they permit concentration on control without the heavy burden of drawing, modeling, movement and all the elements of creative work. It is impossible to prescribe a set number of problems — they should be persisted in until a degree of control and confidence is achieved.

Many professional pen drawings are executed entirely or largely in line. Drawing in pure line has certain severe limitations but it is much more expressive and versatile than is commonly believed.

After having some experience in producing varied kinds of line the next step is to utilize that ability in depicting a form. A fairly simple form, such as a leaf, would be excellent for a beginning. Make a careful drawing in pencil of a leaf. Over it thumbtack a piece of tracing paper, tightly without wrinkles. With a pen trace the outline of the leaf with fairly even pressure. Then shift the tracing paper and trace with a modulated line. Make tracing after tracing, changing the pen point from time to time and varying the type of line and the speed of execution. You will finally have a sheet of greatly varied renderings. Analyze them and decide which you think are most effective.

The method of working in ink outline is the easiest approach to actual ink rendering, but behind it looms the problem of draughtsmanship. The bare and unadorned outline focuses attention on the form depicted; on the drawing. The outline conceals nothing and reveals all. The faults of the inadequate draughtsman are exposed. So we are forced into the foregone conclusion that to master pen and ink one must master drawing. Pen and ink is a draughtsman's technique.

The whole procedure of making ink drawings on tracing paper laid over a master drawing is the wisest one for the student to follow. Countless renderings can be made without harming the master drawing. The fear that most students have when rendering an original drawing, the fear that some or all of the accuracy and quality of the drawing may be destroyed by the rendering, is banished. The student can work freely and confidently, knowing that a fresh start can be made in a few seconds by shifting the tracing paper. And tracing paper is an agreeable surface on which to work. It does not have the variety of texture of some heavier papers, but it is often used by professionals in their finished work.

An easy form, such as the leaf, should be followed by the other forms that are not too difficult. The student should utilize the forms that surround him in

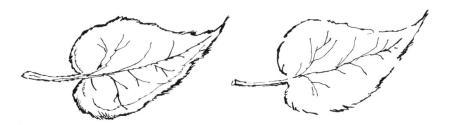

45

everyday life — chairs, windows, cups, cans, shoes, lamps, books, letter boxes, telephones; any of the multitudinous shapes of the modern world. This is not merely gathering material for ink rendering; it is opening one's eyes to the shapes of the visible world, stocking the mind with pictorial material that will be used creatively through the rest of one's life.

Each object or group of objects should be rendered with different pens and in different ways until one has developed a confident way of one's own. The pages of this book are filled with many kinds of pen pictures, a large number of them in whole or partial outline. They are there to be studied and emulated but at the end of the apprentice days lies the goal of independent and individual craftsmanship. Each practice session can bring that goal nearer.

HENRY C. PITZ
Illustration from King Arthur
Doubleday & Co.

46

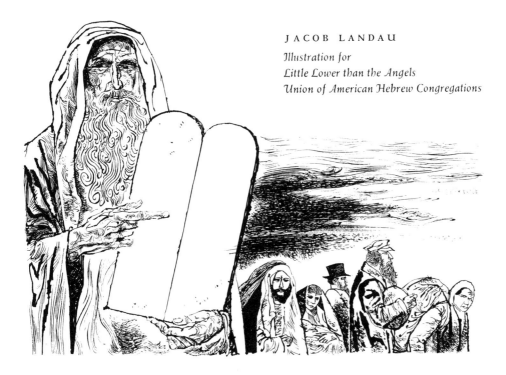

JACOB LANDAU

Illustration for
Little Lower than the Angels
Union of American Hebrew Congregations

6: *Tone*

AS SOON AS TWO INK LINES are placed in proximity, a tone is created. In the ink techniques (except for absolute blacks), tone is a combination of black lines or marks and the intervening white spaces; the eye, at a little distance, tends to ignore the individual shapes of each line and white space and accepts an area as a light or dark tone.

Those who have practiced the exercises recommended in the preceding chapter have already produced tones. The squares of individual lines running parallel to each other are blocks of gray tone. It is true that when pen lines are about a sixteenth of an inch or more apart the eye is more likely to be conscious of them as individual lines, but when lines are close together it readily accepts them as tones. The use of parallel lines to produce a tone is by no means just a student exercise; it is a common method used by many artists.

Let us utilize the device of producing tones by parallel lines for a few more exercises. On a fresh sheet of board or paper covered with two-inch squares, begin with horizontal lines spaced about a sixteenth of an inch apart and gradually draw them closer and closer to each other until only the merest sliver of white paper shows between. This tone, of course, graduates from light to dark. Execute some squares graduating from dark to light and then change the angle of the stroke and finally vary the character of the stroke. A sheet filled with such varied blocks of tone should open one's eyes to the possibilities of tonal effects in ink. There are many other ways of producing pen tones but before engaging ourselves with these, we should pause to examine just what tones are readily available to us in this medium.

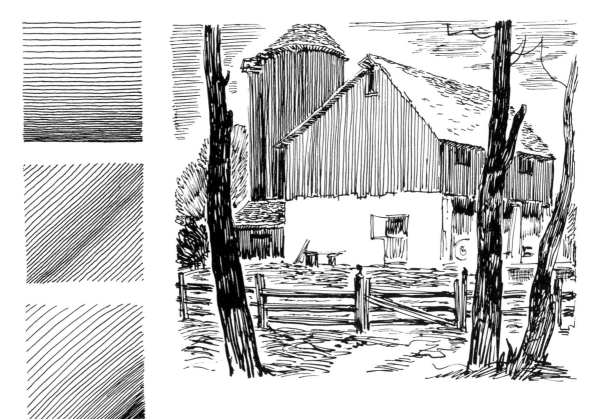

Pen and ink requires great simplification of nature's gamut of tone. It cannot easily report great subtleties of tone, but it seizes upon this limitation and glorifies it. It resorts to a very simple scale of tonal values and benefits by the sparkle and brilliance which this restricted palette encourages. Between white at one end of the scale and black at the other, it is difficult to achieve more than a few gray tones in ink. In fact most pen artists use about five or six readily identifiable tones.

Let us make for ourselves a very simple scale of pen values, which will incidentally test our perception of tone intervals. Pencil in five one-inch squares. The first will be left white, the last will be inked in solid black. In the center square we will line in a tone which we will try to make a middle gray — midway between white and black. That means that our tone should contain about equal amounts of black lines and white intervals, so the spaces between the lines should be about the same width as the lines themselves. In the second square we will line in a light gray, midway between white and middle gray by allowing the spaces between the lines to be about twice the thickness of the black lines. And in the fourth square there will be a dark gray, halfway between middle gray and black with the white spaces about one-half the thickness of the black lines.

These values are not being measured scientifically, but we are training our eyes to measure tonal distances and our hands to record those judgments. The scale may have to be repeated a number of times before we achieve a fairly accurate series of intervals. But with this simple scale many pictorial problems in pen and ink can be solved.

Scale of five values

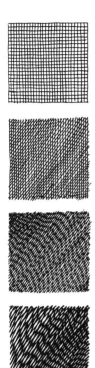

The disadvantage of the scale we have created is that our tones have only been expressed by parallel lines. It would be possible to build an entire picture using only parallel lines but it would be a stunt. We must seek more varied ways of expressing tone.

Even from the few simple exercises we have practiced we have discovered that using one set of parallel lines to produce a dark tone is difficult and mannered — it is difficult to retain a tiny sliver of white between the heavy black lines. But if we superimpose one set of parallel lines on another at varying angles we arrive quickly at a dark tone that is more spontaneous and less mechanical. This is, of course, the *crosshatch* which is such a common device of pen artists. So new avenues are opened for tonal expression.

In a new set of squares, begin a series of crosshatchings. One may begin by drawing the two series of lines at right angles. A net-like tone, rather deliberate and mechanical is produced. Square by square the angle of the two sets should be decreased. When the angle becomes acute we are beginning to execute the most widely used type of crosshatch. These sharper angles produce a lively tone; the acuteness of the lines gives a sense of movement and rhythm and the tiny lozenges of white between the lines give sparkle and vivacity.

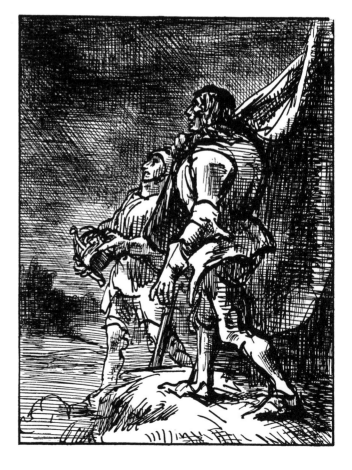

WARREN CHAPPELL
Illustration for Richard III

The first sheet of crosshatching should be done with selfconscious care so that the procedure is imprinted on the mind. An effort should be made to start and stop the lines at the penciled edges of the squares, for in professional work it is often necessary to bring tones to a definite edge. One set of lines should be allowed to dry before superimposing the second, because wet lines usually thicken or clog at the intersections.

With these experiences with a new device let us lay out another scale of tonal values, this time five tones of gray in addition to black and white. We proceed in the same way as before, establishing middle gray first. We now have a light gray and light middle gray respectively one-third and two-thirds of the way between white and middle gray, and dark middle gray and dark gray, one-third and two-thirds the distance between middle gray and black. It is not likely that the right intervals will be realized at the first attempt; some trial and error is almost certain to be a necessity. The student will discover that while the crosshatch gives admirable dark tones, it is not as satisfactory for the lighter ones. Single lines are still more satisfactory for the very light tones.

In actual practice, most pen artists make little effort to establish very light grays, because the method tends to be clumsy and calls attention to itself. They often do one of two things or both. Sometimes, with a natural instinct for tonal simplicity, they abolish the lightest grays, or if there is some particular need for expressing them, they do so by indirection. Knowing that two or more lines, even if used only to define forms, create an illusion of tone, they cleverly hint at this tone by a few delicate but descriptive lines. For instance, a problem of a white cloud in a light sky might be solved by a delicate, broken outline defining the cloud form and then a few staccato lines running from the cloud outline into the sky will give an illusion of a very light sky tone.

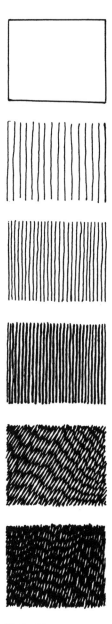

Seven tone scale

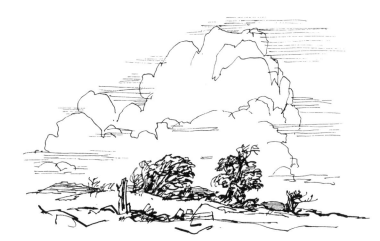

51

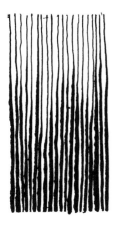

An additional step is practice in the modulation of tones. Fill a sheet with rectangles one-inch wide and two-inches high. Using straight lines, modulate from light to dark and dark to light by increasing or decreasing pressure on the nib. Then modulate tones by the crosshatch method. Combine crosshatching with modulation of the individual lines. For some of the darkest crosshatched tones use a third series of superimposed lines.

Although, up to this point, only the simplest problems have been practiced, nevertheless, command over some of the elements that go into the making of pen pictures has been attained. There is the ability to produce lines and tones, modulate those lines and tones, and with this goes an acquaintance with pen and ink's particular scale of values. All this is valuable experience that may be presently put to work.

A final sheet should be covered with large areas of tones. These areas should not be rigid squares or rectangles, just indefinite islands not smaller than three inches in height or width. To traverse these large areas with continuous lines will be seen to be difficult. There may be times when this is desirable but most pen artists break up long sweeps into several strokes. The length of a pen stroke depends a great deal upon the individual. The beginner often finds that he can draw with ease a line scarcely more than an inch. With practice longer strokes become easy, particularly if the wrist motion is used.

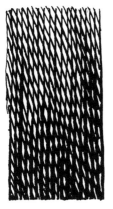

These irregular areas should be covered with lines of a natural length, one linking with another to give a feeling of continuous tone. Lines should be drawn in all directions, and all kinds used, curved, hooked, meshed, crosshatched, wriggled, and any other that develops under the pen. All this is building up knowledge of what the pen will do and teaching the hand to obey.

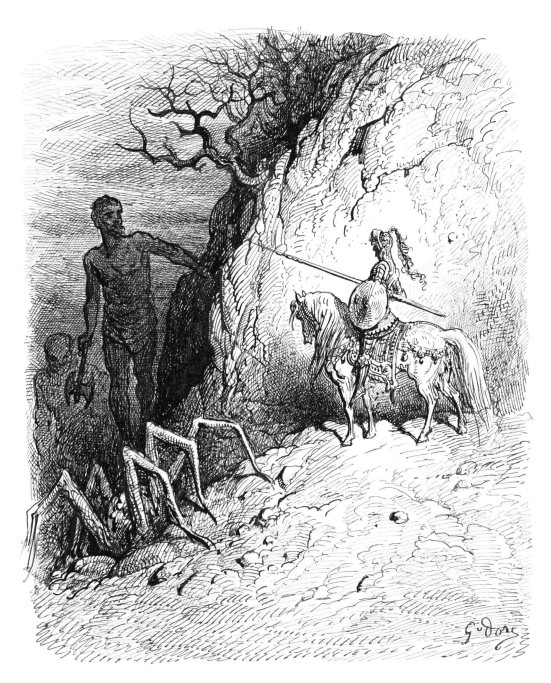

GUSTAVE DORE
*From the collection
of the author*

The next problems in tone can have a more pictorial nature. As soon as we think of tone in a pictorial sense we are likely to think of light and shadow at the same time. Tone is used to express light and shadow but they are not the same thing. Tone can be used without involving itself in light and shadow and for our first problems let us avoid the complexities of light and shade and use tone in a simpler way.

One way in which a graphic artist utilizes tone is by thinking of it only as an interesting pattern of whites, blacks, and grays; to regard it as a way of creating an arresting monochromatic design. It is used particularly as an adjunct to a line drawing to give it more accent and power as, for example, in the small drawings in the margin.

For the first problem let us take a fairly simple line drawing of a landscape or still life and, tracing off a number of linear replicas, try in each one to arrange a different distribution of tones. One for instance might be tried with just a single accent of black while another might have a fairly elaborate pattern of grays. The object is to think of the effect, the pattern, and to open one's eyes to the great variety of impacts that are possible by just a few shifts of tone. This is an imaginative approach to picture-making and can lead to great freedom of pictorial expression.

Another set of problems may use the same line drawing, or another if desired, and this time while the same approximate tonal scheme should be used through the series, the *way* the tone is applied should vary. All types of lines and strokes should be tried, the point being to become aware how much influence the *way* a tone is handled influences the impression the picture makes. Not only the *quality* and *thickness* of line make marked differences of effect but the *direction* too. The examples on the opposite page will give some indications of what we are working for.

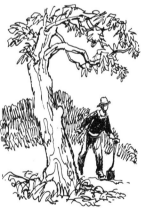

Various distributions of tone in the same composition

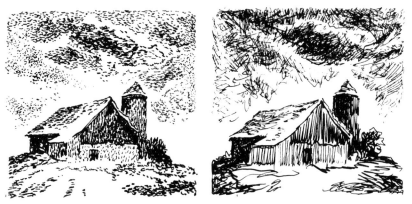

The same composition, using approximately the same tonal values, can still be greatly varied by the kind and direction of stroke used, as can be seen in the examples on this page. In the little landscape the use of radiating strokes gives an explosive and dramatic effect; the short dash technique indicates a more restful and relaxed atmosphere and the free, scratching technique lends a nervous and energetic look to the same picture.

In these two figure spots, stressing the vertical lines seems to give a feeling of height, elongation, and a certain amount of repose. The short curlicue strokes give a busy and restless look to the same composition.

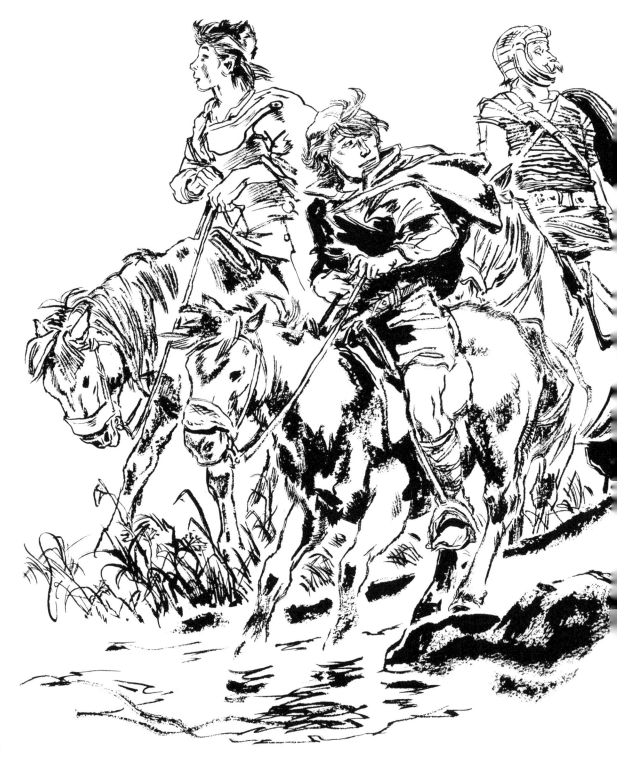

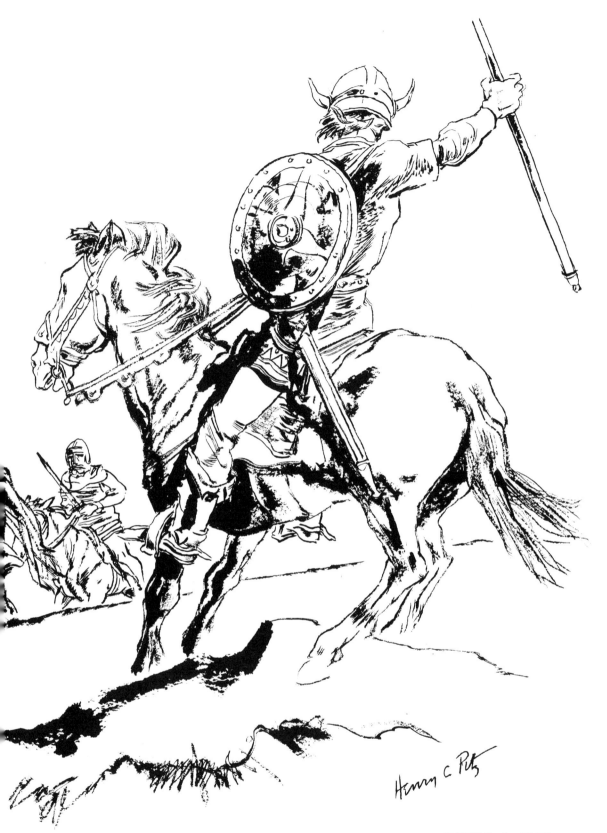

HENRY C. PITZ

Pen and brush drawing for
The Vikings
Random House

There should be a third series of experiments in tone. This time we should attempt to record the effect of local color in tone. Tonal local color is the relative lightness or darkness of an area. In order, at this point, to avoid the complications of strong light and shadow, we should draw some objects indoors, away from any direct source of light. Actually, of course, any object that is visible contains light and shade but we are minimizing it so as to see our objects and areas flatly — one tonal area against another. We will be practicing an artistic convention — like the outline, something which does not exist in nature but which for ages has been a valuable graphic expedient. We will look at our subject with half-closed eyes and estimate the relative darkness or lightness of each area. It might help to have with us one of the scales of pen values which we have previously made. This scale with its few values should help us to simplify the subject before us; subtle differences of tone should be ignored and merged into one. When we feel we have a clear notion of the relation of all the principal tones in our composition we will be ready to pick up the pen and execute them. On this page are some small compositions done in this way. Notice that where two objects of about the same tone impinge, the outline is often resorted to.

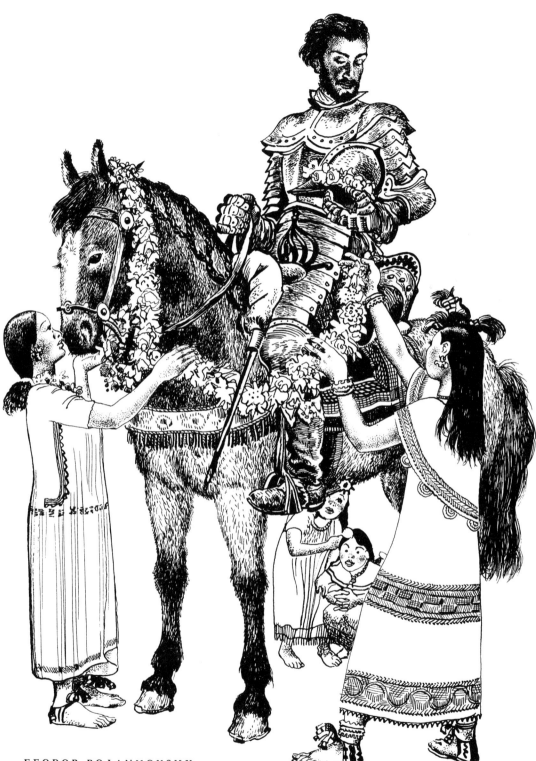

FEODOR ROJANKOVSKY

Illustration from
Cortez the Conqueror
Random House

HENRY C. PITZ

Illustration for Bandoola
Rupert Hart-Davis, London
Doubleday & Co., New York

HENRY C. PITZ
Crow-quill pen drawing

The drawing to the left is almost entirely a line drawing. The one above uses tone principally to heighten the effect; in other words for design reasons. The Chapman drawing on the facing page uses its blacks for design reasons but they fulfill the dual purpose of making also a statement about local color.

FREDERICK T. CHAPMAN

Illustration from
The Iceland Fisherman
Alfred A. Knopf

Up to now we have rendered objects in three different ways which actually involve three different ways of thinking. First in line, which will seem natural enough for all even though it is an artistic convention not to be found in nature. Second, using tone as an accent to heighten an effect or create a more interesting arrangement. This, again, is a convention and the distribution of tone is dictated — not by nature — by the demands of design. Third, the use of tone to depict local color. This necessitates banishing light and shadow from our minds and seeing tones in a special way.

The student who has successfully completed these three steps has not only made a little more progress in pen technique but has acquired a versatile outlook upon his picture material. Although these three approaches have been separated for purposes of instruction and practice, they are and should be combined at will.

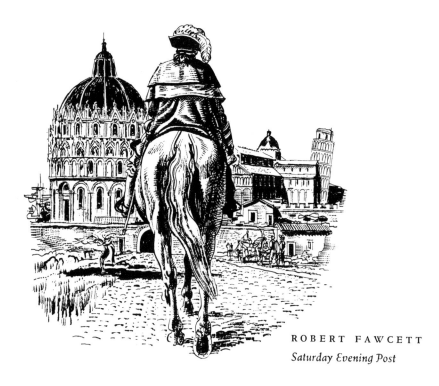

7: *Light and Shadow*

THE WORLD OF LIGHT AND SHADOW is a more complex world for the artist than that of line or tonal local color. Light and shadow reveals the world of substance to us and it is a world of bewildering possibilities. No artist will exhaust its possibilities, even in the longest lifetime, so here lies the promise of endless exploration.

Let us begin by being arbitrary about light and shadow. Let us assume that the only method we have of expressing it graphically is by using black for shadow and white for light areas. There will be no half-lights, half-shadows, no blendings or modified tones. Let the student look at the scene about him and decide what portions are shadow, what light. Half tones will have to be pushed into one category or other and some decisions will be difficult. But this is an exercise of the utmost value to the student, for the pen artist, because of the limitations of his medium, must frequently drastically classify his values.

Small scenes from nature, still-life groups or the posed model should be drawn and rendered in this arbitrary way. In the margin are a few suggestive sketches and in the following pages are more. There could be no better practice than this uncompromising separation of tones. At first objects should be posed in a strong light to make the contrasts more obvious.

Some objects should be studied in artificial light. A moveable shielded electric light is best for it can be shifted at will. The student should study the changes in appearance that the shifting brings about. He will discover that where the shadow line falls is very important. In some positions it creates a lighting which is much more descriptive than others. These more revealing lightings should be remembered and analyzed, for it is the artist's task to disclose the significant things and one secret of pictorial eloquence is the ability to make the shadows talk.

All this, of course, is a Spartan and special way of looking at light and shadow but it makes for strength. Many have a tendency toward endless blendings of minor tones with a resulting boredom of modeling and flabbiness of form. Once an artist is able to see the black and white world in this bold way, he is not likely to get lost in trivial and irrevelant passages of tone.

But the grays need not be abolished. They are of importance too, when selected wisely and for their significance. They soften the harshness of black and white contrast, explain local color, and reveal the modeling of certain minor planes which may need to be emphasized.

ML4858

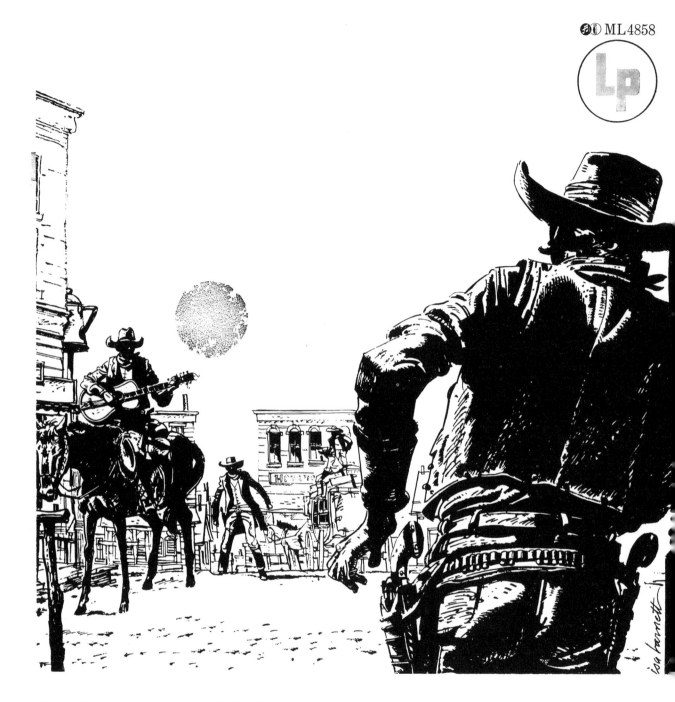

One could scarcely ask for a more drastic pictorial statement in black and white than this bold brush drawing by Isa Barnett. So much of its effectiveness stems from the knowing placement of each form and the wise selection of what shadow edges to use in order to clarify the form. Here is a drawing used for advertising purposes which has done exactly what the student is attempting in these exercises.

ISA BARNETT
Columbia Masterworks

ROBERT MCGOVERN
Brush drawing

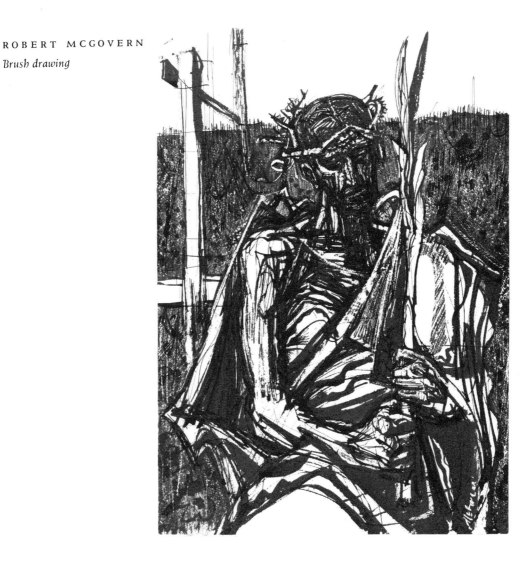

This bold brush drawing offers a great variety of
blacks (some of which escape reproduction). They
are achieved by some brush strokes which carry
a light charge of ink and by scraping many of the
areas with a razor blade.

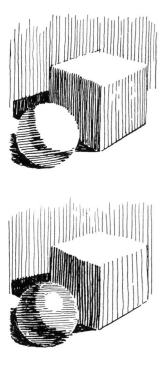

Here are pen renderings of a white cube and sphere. Compare them with the arbitrary black and white renderings we have been doing. Each type of rendering has its own power but the cube and sphere drawings reveal more completely the forms we are dealing with. By using a few grays we begin to reach out toward a more three-dimensional concept.

The cube, lit by a light to the right and overhead, receives most of its light on the upper surface. This is white, as is the plane on which the cube and sphere rests. The right side receives a little less light than the top, so is grayed a little with pen lines as is the background behind it. The shadow side is quite dark, of course, and the cast shadow still darker. This is a very simple tonal scheme but it expresses adequately the sense of light and solidity of the cube.

Now, study the sphere. It has no edges or sharply defined planes to intercept the light but its rounded surface gradually turns away from the source of light. The area where light and shadow meet is a blended one and, as the surface curves away into deep shadow, it reaches a point where light is reflected into it from the wall and the plane on which it rests.

This *reflected light* — this bouncing back of light from an adjacent surface into a shadow — is a common phenomenon in nature and should be searched for and studied. Reflected lights help to explain both the surfaces which reflect the light and those which receive it. Sometimes the artist becomes so interested in them that he exaggerates their number and tonal values and his drawing becomes riddled with holes and spots of reflected light. Reflected lights are minor lights and must be held in relationship to the main lights. Half-closing the eyes makes many unimportant lights and shadows disappear. If they disappear readily they are probably of too little importance to retain in the picture.

If a sphere of darker color and shiny surface is studied, another phenomena of picturemaking importance is encountered — the *high light*. In rendering this sphere we discover that its color has absorbed some of the light rays so that the lightest side appears as a pale gray tone except at the spot where the most direct rays strike and are reflected back to our eyes. This is the high light. It is valuable to us for expressing the direction of the light and the reflecting power and shape of the surface on which the light falls.

The concern with simple forms like the cube and sphere is not a kinder-garten gesture. The mastery of these two forms will carry one a long way toward understanding the infinitely varied forms of nature — she hides these essential and fundamental forms under the most perplexing disguises. Artists of all times have searched the bewilderment of nature for common denominators and found them in the simple geometric forms of the cube, cone, cylinder, sphere, and pyramid.

A working knowledge of light and shadow cannot be built up in a day. One must be prepared to give a great deal of time and effort to the drawing of all kinds of objects and to independent observation of everything in nature. Progress depends largely on ability to retain impressions, for we draw much more from accumulated knowledge than from the sight of the moment. Everyone should make numerous studies from simple forms. It is not necessary to buy a white cube and sphere. Paper boxes will do just as well, as will balls, books, oranges, eggs, and bottles and hundreds of other common objects.

The first step is to determine the lightest light and the darkest dark, and the exercises in dividing subjects into stark light and dark should have helped to develop this discrimination. Then with half-closed eyes the principal grays should be appraised. They should be judged in relation to the lightest light and the darkest dark. Is a certain shadow halfway between, one quarter or three quarters? Thinking of grays in such simple divisions gives a reasonable and work-able tonal scheme. If a tone seems too subtle for easy assessment, incorporate it into another one, thus simplifying the composition.

STEVAN DOHONOS

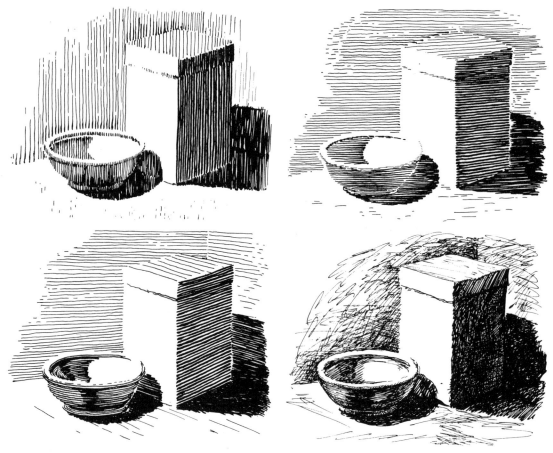

Experiments in technique

In all this study we have said nothing of technique, and presumably the student has been so intent upon expressing his judgment of values that he has let the pen go where it will. This is right, but let us digress a moment into technique. On this page is a simple object study which has been rendered in a number of ways. Examine how the changes of technique have changed the appearance of the sketches. Merely the difference in direction of the lines alters the effect. Horizontal lines tend to make things wider; vertical lines make them seem taller; rounded lines give more feeling of bulk. Lines following the con-

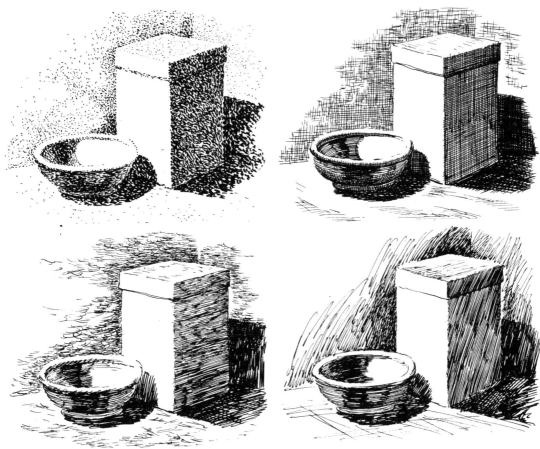

Various renderings of the same subject

tour of a surface emphasize that surface; haphazard lines tend to destroy the integrity of the surface. Look how the stipple drawing gives an entirely different feeling of texture and material from the linear drawings.

So the kinds of line and tone used are of tremendous importance. The student should make a number of such experiments. On tracing paper overlays, see how many ways of rendering the same drawing can be worked out. The principles of technique that are discovered in these simple drawings will be used later in the most involved compositions.

69

After sufficient time has been spent in practicing from simple and preferably white or light-colored objects, more elaborate combinations of objects may be set up. They may, and should, be drawn from all possible sources. Not only those things which are usually considered artist's property — such as dust-covered bottles and beautiful pottery — but any of the objects that surround our everyday life: table lamps, books, magazines, cans, dishes, spoons, matchboxes, chairs, garments, and all the other paraphernalia of daily living. This will not only give a great variety of forms to explore, but if the student is interested in becoming an illustrator, it will bring him in contact with the material that will be utilized in many of his later illustrations.

A new element will appear in these object arrangements — that of local color. Local color is the actual tone and color of an object, irrespective of the accidental and passing effects of light and shadow. Many of the objects we are now drawing from will be brightly colored. Obviously we cannot render the color but we can render the *tone* of that color. We will not be interested in the redness or blueness of an object but in how *light* or *dark* the red and blue are. In other words, for the moment we are banishing color from our vision and seeing these setups as monochromatic compositions.

We discover certain things — a very dark object is still fairly dark on its light side no matter how much light floods it (unless the surface is very shiny and reflects a glare of light to our eyes). We may have the thought that all things in shadow are automatically darker than all things in light. Local color sometimes makes objects in light, darker than very light objects in shadow. Toss

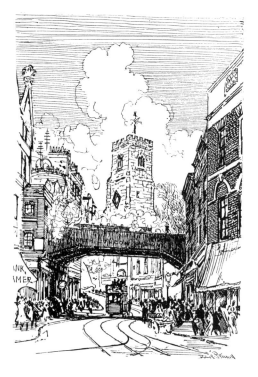

JOSEPH PENNELL

In this drawing, tone is used principally to suggest local color and for design fulfillment. True enough an effect of light is suggested by the shadows under the bridge and this one bit imparts a feeling of light to the whole picture. It shows how, in the hands of an expert, a small suggestion can permeate a whole picture.

Coll, in his drawing, is mainly concerned with an effect of dramatic light, but at the same time he has used his tones to suggest local color. Gibson's first concern has been a bold statement of local color but of course he has not neglected to indicate lighting. So, the tones we use in pen and ink usually do not serve one purpose alone, but a number. Each artist is inclined to emphasize one pen purpose more than another according to his temperament.

JOSEPH C. COLL

CHARLES D. GIBSON

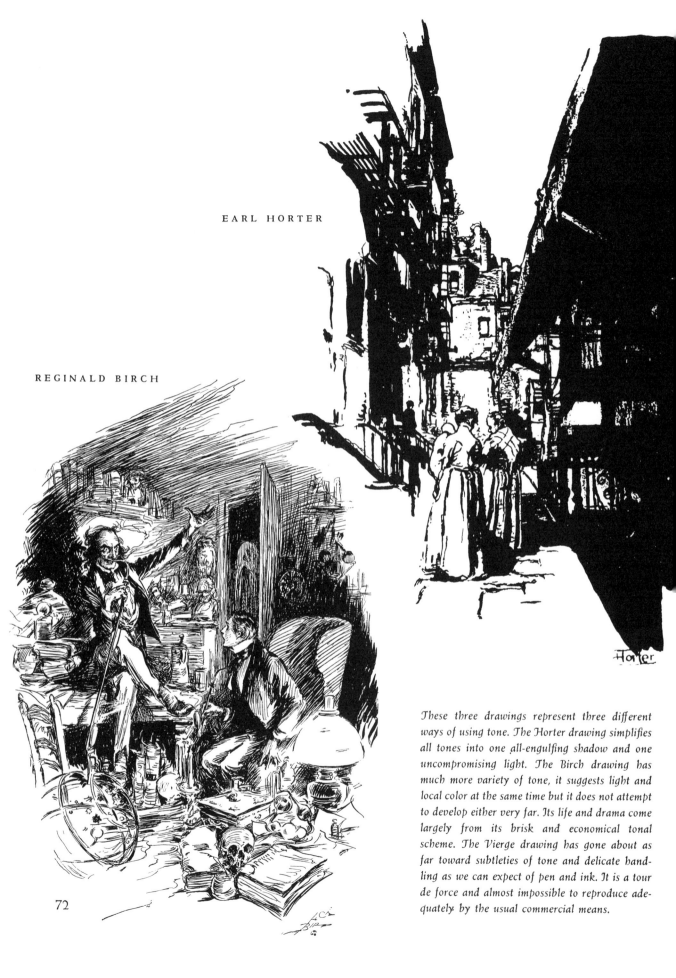

EARL HORTER

REGINALD BIRCH

Horter

72

These three drawings represent three different ways of using tone. The Horter drawing simplifies all tones into one all-engulfing shadow and one uncompromising light. The Birch drawing has much more variety of tone, it suggests light and local color at the same time but it does not attempt to develop either very far. Its life and drama come largely from its brisk and economical tonal scheme. The Vierge drawing has gone about as far toward subtleties of tone and delicate handling as we can expect of pen and ink. It is a tour de force and almost impossible to reproduce adequately by the usual commercial means.

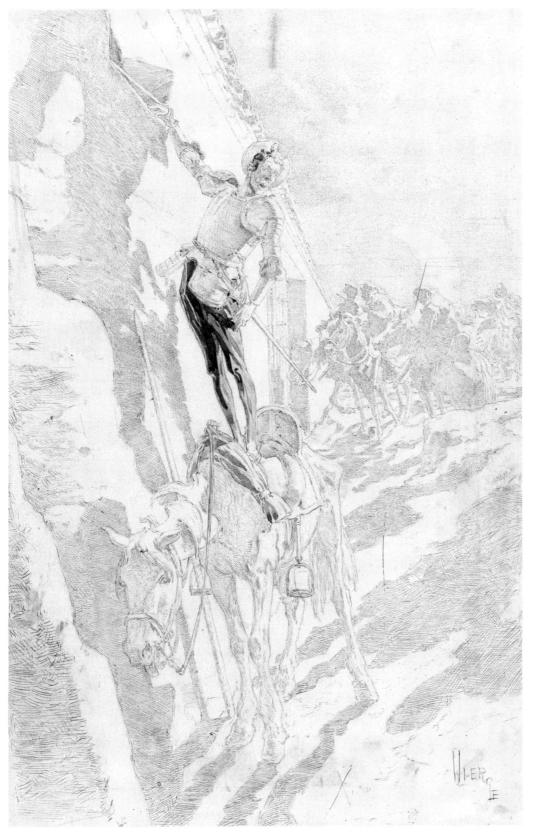

DANIEL VIERGE

*From the collection
of the author*

73

a white handkerchief on a black garment and place them so that a shadow line cuts across both. The garment in the light is darker than the handkerchief in the shadow. This shows how much local color must be reckoned with.

No set number of problems will guarantee an understanding of light and shadow. The student must sit in judgment on himself. He must learn to make an honest estimate of his own progress and reach an equally honest determination to repeat his efforts until he feels a sense of confidence in his results. These studies of objects can be continued indefinitely. They are susceptible to infinite combinations of sizes, shapes, textures, lighting, and relationships. The illustrations in this book can suggest many ideas but the student should go beyond them with inventions of his own. This continued practice accomplishes not one thing, but many. The student is learning not only light and shade but drawing, technique, and composition at the same time. That is a large portion of the whole matter of picturemaking.

LYND WARD
Illustration for Rabelais
Limited Editions Club

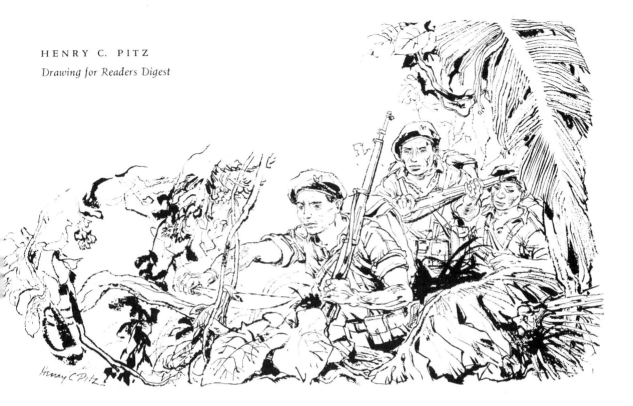

HENRY C. PITZ

Drawing for Readers Digest

8: *Building the Picture*

THE COMPLETED PICTURE is the goal of professional and student alike and the beginner cannot be blamed for wanting to put finger exercises behind him and plunge into elaborate pictorial schemes. Without some drawing and compositional experience and a moderate amount of practice with brush and pen nothing but disappointment can be expected. But it would be pedantic to wait until all these elements were under command. Everyone learns to make pictures by making them and all have learned by failure as well as success.

The first thing to emphasize is that the novice should not plunge ahead, drawing his composition hastily in pencil on his sheet of good paper or illustration board. The operation must be planned as most professionals plan it. The sheet to be inked will not work well if covered with pencil lines and erasures.

The drawing and composition should be worked out *completely* before being transferred to the inking sheet and the best surface for the trials and revisions of drawing and compositional problems is tracing paper. By using tracing paper the good portions may be saved by tracing through to a fresh sheet or by cutting out and taping it to another sheet. Numerous versions can be shifted around and adjusted to each other when on tracing paper and yet the whole arrangement is visible. This is the way most professional illustrators, who must work quickly and efficiently, lay the groundwork for their finished pictures.

Too much emphasis cannot be laid upon this groundwork of a picture. Students habitually rush ahead to the inking, hoping for a miracle to happen at that stage. It doesn't. The preparatory donkey work may seem boring to some, but only for those who would like all the pleasure of picturemaking without the trouble.

Once we have arrived at a satisfactory composition, well drawn in line on tracing paper, we are ready for the final and less difficult stage. And we are ready, backed by confidence in our groundwork. We will trace it on to our final sheet, but it still remains as a master drawing to be referred to if necessary. Even if we make a botch of the rendering, we merely have to use a fresh sheet and retrace.

Some artists trace through carbon sheets but most coat the back of the tracing paper with soft pencil and, tacking it firmly over the clean board or paper, trace with a stylus or the end of a watercolor brush. Tracing with a stylus will leave our master drawing as it was. After tracing, the faint lines should be strengthened with pencil but not too strongly. Over-penciling makes it more difficult to establish clean pen lines.

When all the drawing is firmly established we are ready to ink, but only if we have a clear idea of what tones go where. If there is any doubt, a fresh sheet of tracing paper should be fastened over the drawing and our ink experiments carried out on it. In fact, this preliminary inking on tracing paper is a very valuable experience for any student. One is more likely to be confident and daring at this stage because so little is at stake. It should be part of every student's education.

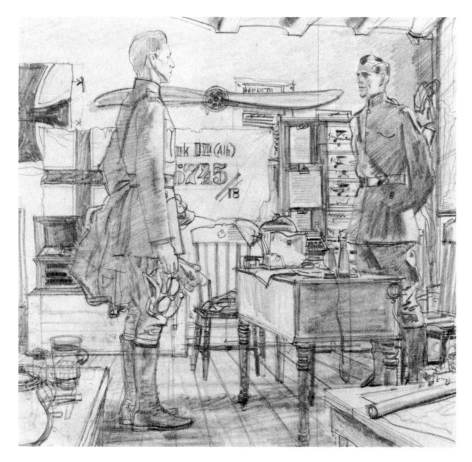

ROBERT FAWCETT

Master drawing on tracing paper
from which the final drawing was traced

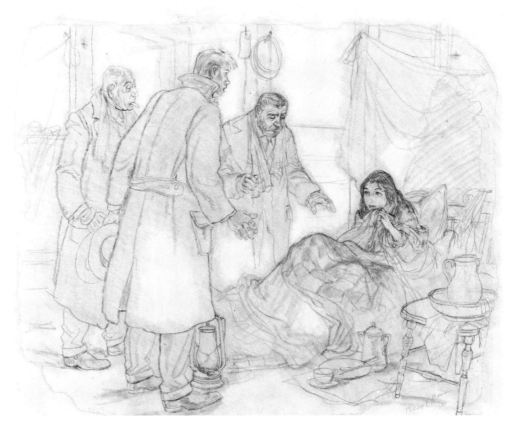

*Pencil drawing submitted
to art director*

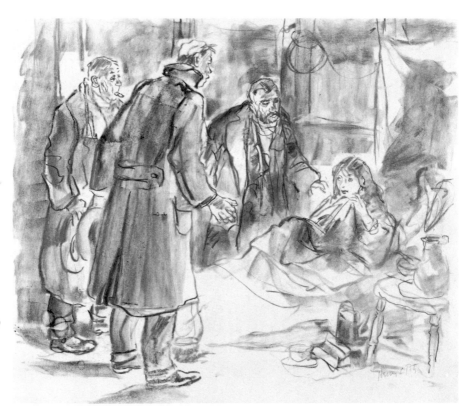

*Charcoal sketch to establish
effect of lantern light*

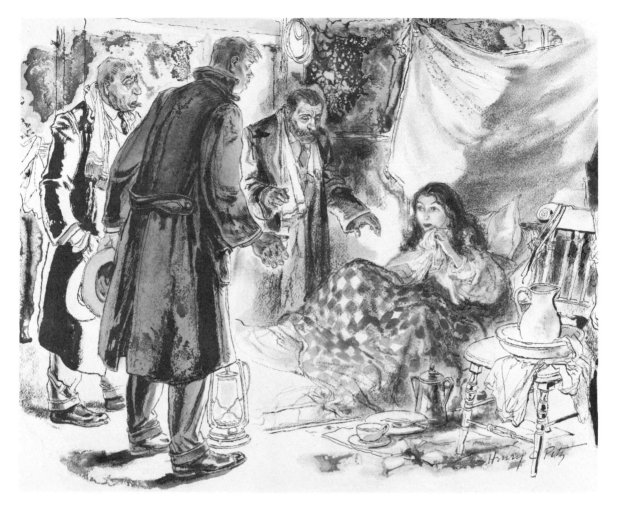

HENRY C. PITZ
Illustration for Colliers

These three drawings do not represent all the stages in the development of this illustration. The pencil drawing was preceded by a number of sketches. In this the drawing and composition has been clarified and it is ready for the art editor's eye. The charcoal drawing was developed from this in order to explore the rendering of artificial light. The finished illustration was traced on Whatman board from the pencil drawing and rendered in brush and ink, ink in wet, watercolor wash and charcoal.

When we are ready at last for the final rendering we again have to make some decisions for ourselves. There is no ironclad rule about where an ink drawing should be started. Many professionals feel the need of a warm-up stage before they are at their best form. Sometimes this means drawing on some odd bits of paper but many warm-up on the drawing itself; but in some unimportant corner — some vague shadow area, a wall, a mass of foliage or a bit of sky. The important thing is to know one's temperament, and be able to sense when one is in good form and when that time has arrived to engage oneself in the crucial parts of the picture. Once one is warmed up there is no reason, except fear, for not attacking the focal point of a picture. After all, success or failure is decided here and, if it is to be failure, the sooner we can discard it and make a fresh start.

If all goes well with the center of interest, the development may radiate from it in any convenient way. Usually there is a pronounced rhythm as an important part of the picture's design. It is wise to follow this; it will help establish the picture's unity. After all, unity is particularly a problem in ink technique because by its very nature it must be executed bit by bit. In oil or watercolor, for example, broad washes and tonal areas may be swept in and vague relationships established throughout the picture before they are made more decisive. This is splendid procedure in a medium which permits easy change but impossible with the almost irremovable character of the ink line. So the ink artist must have a very clear idea of his hoped-for final result as he renders his picture part by part.

Again, let us emphasize that following the natural rhythms of a picture is an excellent way of helping it to hold together as a pictorial unit. Respect the white spaces; they can be vital and eloquent. Hoard them up until the last; if must be, they can always be abolished by a few strokes. If there is a tendency toward timidity or monotony of tone, begin a picture by arranging in the focal center some important form that can be silhouetted black against white or vice versa. Draw in the black shape boldly and allow that extreme of contrast to set the pace for the entire picture.

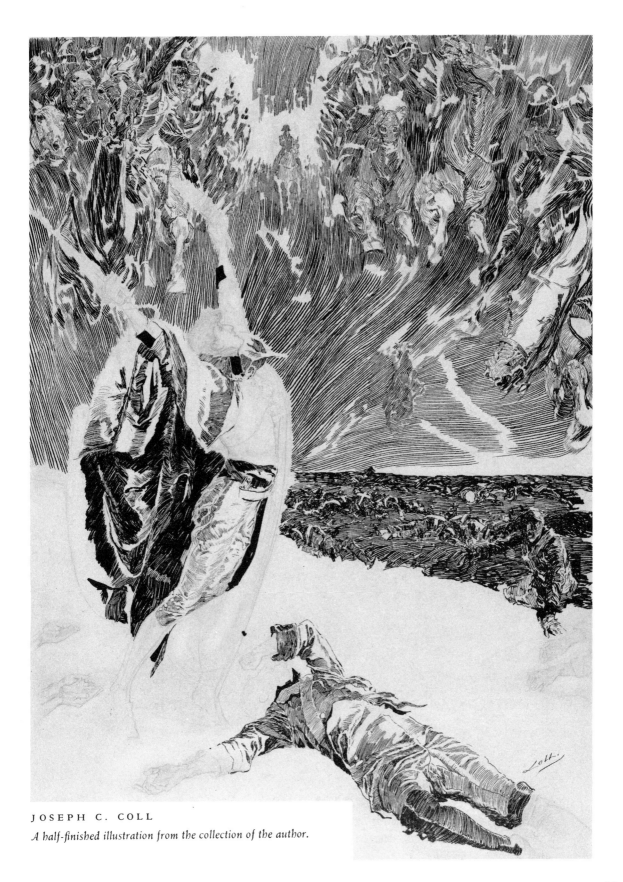

JOSEPH C. COLL

A half-finished illustration from the collection of the author.

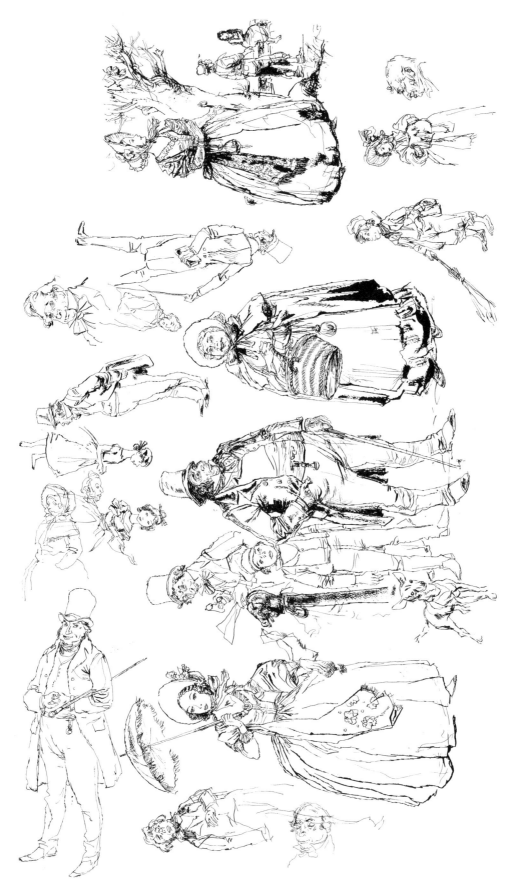

HENRY C. PITZ

A so-called "warm-up" sheet. Drawn by the artist in a search for characterization, costume handling, and a suitable technique to be used in illustrating Dickens' Dombey and Son.

In working on extended pictures, there should be intervals when the artist can lay down his tools, straighten his back and look at his picture from a new distance. At work one has a tendency to see parts — a retreat from the drawing will freshen the eyes and enable one to see the whole.

There is always the danger of doing too much. Ink drawings usually need less stroking of the pen or brush than one would believe. It is better to subtract than add. At the point when a picture seems to be about three-quarters complete is a good time to pause and take stock. At this point, reflection often reveals that perhaps just a few bold, well-placed lines will bring it to a vigorous conclusion.

The use of the brush in conjunction with the pen is a good thing. The brush encourages a breadth of handling that is likely to coax the pen out of any tendency to a fussy and overworked style. It will not be long before the wide-awake student will find his own way of doing things. He will discover which procedures are natural for him and which are antagonistic. No matter what advice he may have from others, no procedure is good of itself; it must work for him. The final test is — will it work for me?

FELIX TOPOLSKI
*Pen and brush drawing from the
collection of the author*

WALLACE MORGAN

9: The Brush

ALTHOUGH THERE ARE NO STATISTICS to prove it, it is probable that today the brush is used as much as the pen in ink drawing. Artists have discovered that in properly accomplished hands the brush can do almost all the things that are possible to the pen, and some things that the pen cannot do. But it requires considerable skill to get the most out of the brush and that skill is usually slowly acquired.

The brush is a very flexible instrument. A small-sized red sable brush, properly pointed, can in one stroke execute a line that will swell from a hairline to a rich, quarter-inch accent. It can change direction easily, twisting about and rounding corners without the sputter and spatter of the pen. It glides over the surface of the paper without laceration and does not pick up tiny paper fibers like the steel nib. It can be used on many surfaces that would be too soft or tender for successful pen manipulation. Finally the brush can be coaxed into many shapes that will render interesting effects.

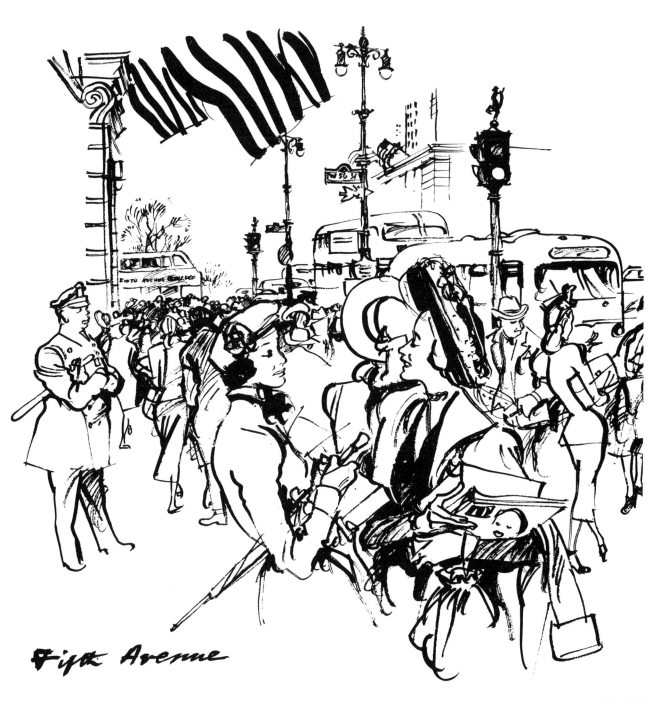

Fifth Avenue

FRANCIS MARSHALL
Brush drawing from
An Englishman in New York
G. B. Publications, Ltd.

JAN MARCIN SZANCER
Brush drawing
American Artist

BIRGER LUNDQUIST
Brush drawing for
Mark Sang
Albert Bonnier Verlag
Stockholm

86

COLLEEN BROWNING
Brush drawing for
Doubleday & Co.

On one hand, working over textured paper, the brush skips over the valleys and leaves little islands of ink on the crests of the texture. This results in broken tones and staccato lines, and the effect can be lively and brilliant. On the other hand, on a hot-pressed or smooth stock, the brush can give a copperplate effect. If the hand has enough skill, it can create lines of great sharpness and precision, even of mechanical exactness.

The brush has a wide range. It is a mistake to assume that it is fitted only for the heavier, bolder tasks of ink drawing. It can produce lines as delicate as a crow-quill and from there on up the only limit is the size of the brush.

While the brush can execute small-sized, delicate drawings as well as the pen, it shows to particular advantage in the large sweeping drawings. The brush artist can work from the shoulder, with breeze and gusto, if he wishes or, like most pen draughtsmen, may use the heel of the hand, the forearm or the elbow as an anchor on the drawing board. As a matter of fact, the freedom of the brush has had a decided effect upon many pen technicians. They emulate its sweep and power and, although handicapped by the reluctance of the pen to negotiate quick turns and return strokes, they are imparting a new vitality to the art of the pen.

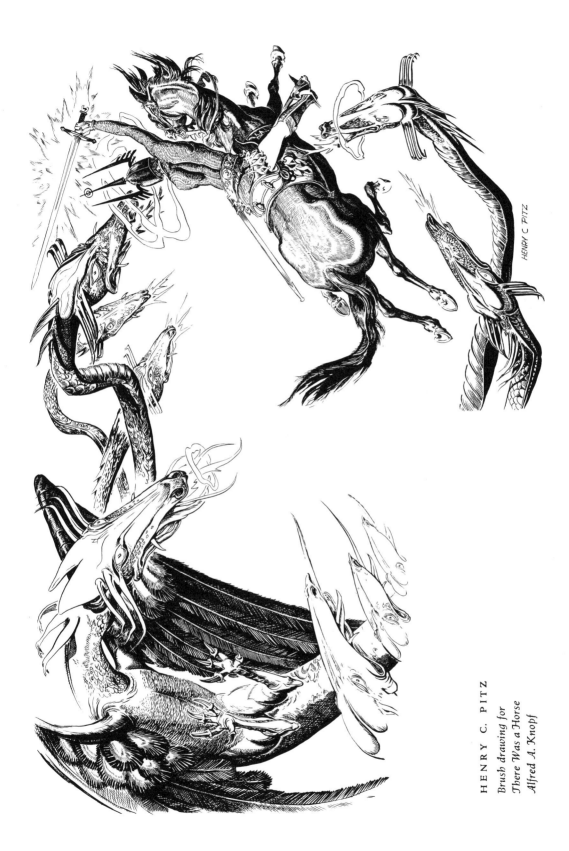

HENRY C. PITZ
Brush drawing for
There Was a Horse
Alfred A. Knopf

HENRY C. PITZ

Dry-brush

The brush can perform two highly interesting and useful techniques. Those of the *dry brush* and the *split brush* or *multiple line.*

The dry brush produces lines with edges of fascinating irregularity and tones that in the lighter ranges are flecked with tiny irregular spots of black and in the darker range are black flecked with minute islands of white.

The method is simple. It does not work at its best with the very smallest size brushes but numbers 3 and up (red sable) are excellent. The ink-charged brush has most of the ink wiped from it, first on the mouth of the bottle and then on a blotter or scrap of paper. The hairs of the brush should be spread somewhat fanwise by the wiping and then the brush drawn across the paper lightly or with more pressure according to the effect desired. The method only yields the best results on medium or roughly textured paper — some effect can be obtained on a smooth surface but it is limited. With a little practice the brush will deposit ink only on the crests of the paper surface; the more ink in the brush and the more pressure, the more the ink will invade the valleys and tend toward a flat black tone. Scraps of the same kind of paper as that used in the drawing should be fastened to the edge of the board and used for testing each time the ink is renewed and wiped.

A whole series of flecked gray tones is possible in this technique and they supply an interesting contrasting texture to the usual line and crosshatch. Very subtle grays can be produced by this method but these are not usually reproducible by line engraving. If the drawing is made for this method of reproduction the greater subtleties should not be exploited. If in doubt, the areas should be scrutinized under a magnifying glass. If the minute speckles, which compose the tone are black or close to it, the picture should reproduce.

To practice the split-brush technique, the brush, not too heavily charged with ink, is splayed out on a piece of paper. Groups of hairs are induced to

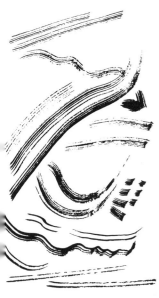

Split-brush

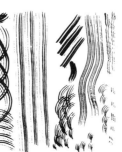

Various brush forms

stand out fanwise with a knife and these groups of hairs make simultaneous lines at one stroke. With coaxing, a brush can be separated into a varying group of points, with varying or uniform distances between them. The split brush is helpful in covering large areas of darker tone, either by a single series of lines or by crosshatching. It is also excellent for indicating certain textures such as the bark of old trees, grass, weeds, and weathered boards.

Old brushes that have become blunted from use are actually more suitable for these methods than new brushes. Good ink brushes, like the red sables, are too expensive to be treated carelessly. They should be washed carefully in water after each using until they are free of ink. Ink left in brushes not only spoils their shape but rots the hairs. After washing, the hairs should be coaxed to a point and the brushes placed point up in a jar or in some place where there is no danger of them being crushed out of shape.

Mastery of the brush, even more than control of the pen, usually demands incessant practice, for we occidentals grow up accustomed to the use of writing instruments with rigid points, the brush being often a strange tool to us. Its extreme flexibility requires greater control than the rigid point.

The best way to introduce oneself to the brush is to use it freely and even recklessly at first, without any attempt at description of form. Make any kind of swirl, blob, line or mark that occurs to you. Doodle and have a good time. If one has had previous experience with the pen, try to forget it for the time being. Try to search out the shapes which the brush naturally makes; and use a variety of papers for this playful experimentation.

Most will instinctively begin by holding the brush in much the same way that a pen or pencil is grasped. After a while the grip should be changed to about halfway up the shaft and later held near the tip. This practice should enlarge ones ideas of manipulation.

After a session of free and uninhibited doodling, which should result in some enlightenment as to brush behavior, and perhaps make one feel friendly toward

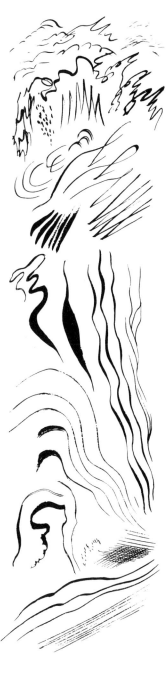

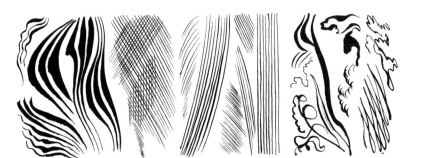

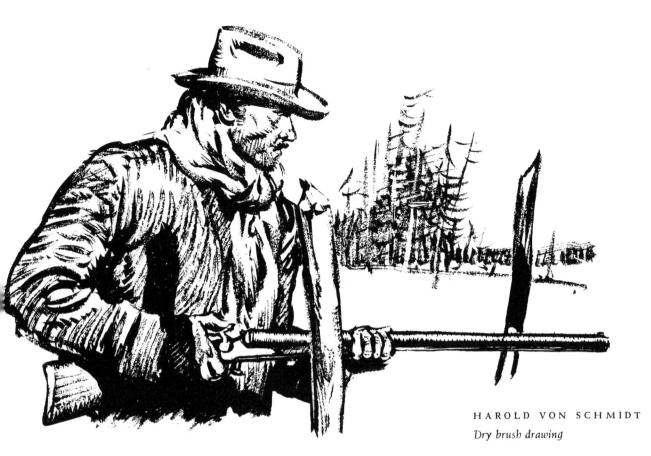

HAROLD VON SCHMIDT
Dry brush drawing

*Japanese brush drawing
from the
collection of the artist*

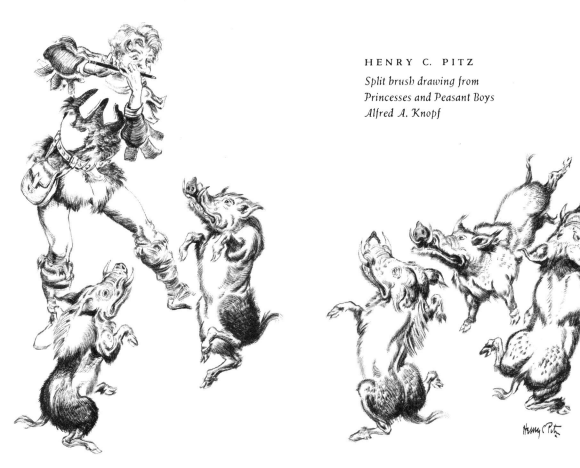

HENRY C. PITZ

Split brush drawing from
Princesses and Peasant Boys
Alfred A. Knopf

Detail of above drawing
reproduced three-quarters
actual size.

the tool, it would be wise to begin a series involving more concentrated control. Draw some very fine lines. One discovers that it is impossible to do this with too much ink in the brush, in fact, the amount of ink in the brush has a direct bearing on the quality of one's line. Of course, the brush must be brought to its finest point — sometimes a little twirl of the tip against a scrap of paper may be necessary.

JAN MARCIN SZANCER

HENRY C. PITZ

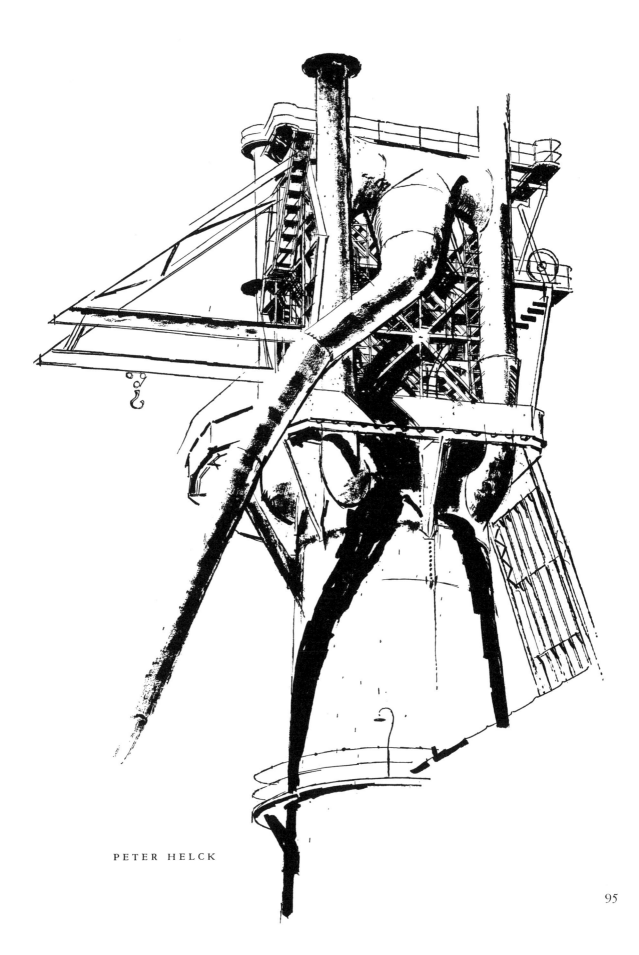

PETER HELCK

Draw a long series of these fine lines, parallel to each other and of reasonable length — at least two inches. Then draw some series of fine lines, more freely and not too slowly, allowing them to curve slightly, following the natural arc of the hand stroke. Next try some of increasing thickness and then a long series of all ways of crosshatching the lines previously used.

Begin a new series of modulated lines, that start lightly and fine and swell toward the end of the stroke and then the reverse, beginning thick and tapering off to fine. Draw some straight and some curved. Some of these series will probably suggest the contours and modeling of some surface or form. So our apparently abstract exercises begin to point toward the ultimate expression of form.

These are all finger exercises, of course. They begin to teach the muscles to do certain elementary things and they educate the eye, too. How long it will be necessary to pursue them will depend upon the individual's inherent feeling for the brush and his gift for coordination. Most should repeat them daily for a long time, even if only fifteen minutes a day are available. Those who already have manual skill at drawing will want to pass immediately into more pictorial exercises. There is no use in being dogmatic about the length or number of the exercises; no rigid set of problems will guarantee success. Their purpose is to stimulate practice — incessant practice.

JAN MARCIN SZANCER

J. S. SULLIVANT
Brush and pen drawing
from the collection of the author

The early steps in dry-brush technique may follow the same path. After the brush is prepared as indicated, it should be dragged across the paper trying to establish blocks of tone of varying densities. Then tones should be graded from light to dark and then various shapes modeled with dry-brush textures. Different kinds of paper should be tried. The paper may be stabbed or patted with the brush for different effects. In short, every experimental idea should be explored.

For exercises in the use of the split brush, one should try arranging the *splits* in different ways and noting what sort of lines each arrangement makes on the paper. The different *split* arrangements should be used in varying series of cross-hatching. Large areas should be covered quickly, for the split-brush technique is a brisk and breezy method and seldom looks well when treated fussily. The brush should be held in different ways and any inventive ideas about handling should be investigated.

The important thing is to explore — to consider these exercises to be an adventure; to become acquainted with the tools that are to serve one a lifetime; to become unafraid of them. If the hand discovers new little ways of handling them, it is a healthy sign that initiative is present and that one is not merely a docile follower of directions.

HENRY C. PITZ

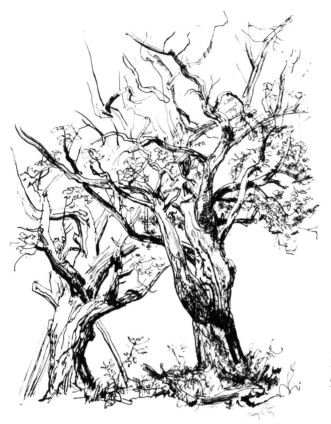

HENRY C. PITZ
Fountain brush drawing

10: The Felt Nib

IN RECENT YEARS a new tool has been added to the collection of the ink artist —
the fountain felt-nib pen or brush. Strictly speaking it is neither pen nor brush but
a distinct instrument in its own right. Like the writing fountain pen, or the special
type of drawing fountain pen it is a most convenient sketching instrument. With a
fountain pen and a sketchbook one is ready for the road.

The felt nib will not make a hairline but it makes a reasonably narrow line and,
according to the nib used, a very broad, brush-like stroke. The stroke has a soft
velvety quality, quite unlike the usual brush or pen stroke. All in all, it is quite a
versatile instrument.

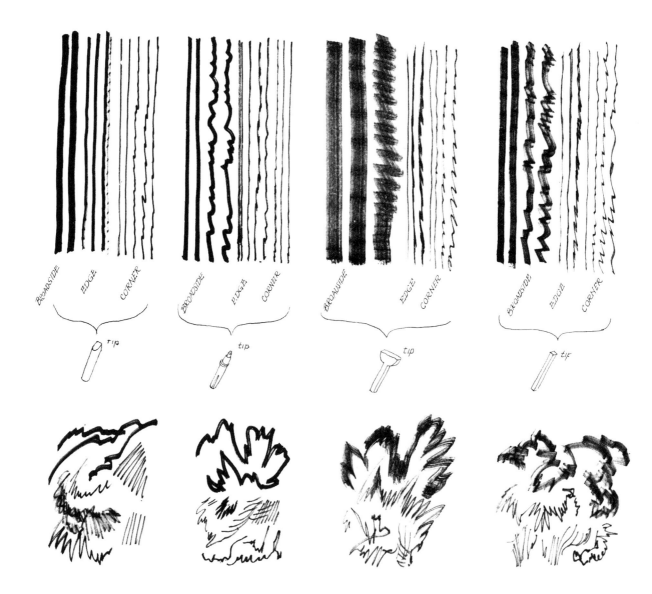

A chart showing the more commonly used felt nibs and the kinds of strokes of which each is capable. These strokes have been made with approximately even pressure. More variation from light gray to black is possible by changes of pressure and by wiping off the nib.

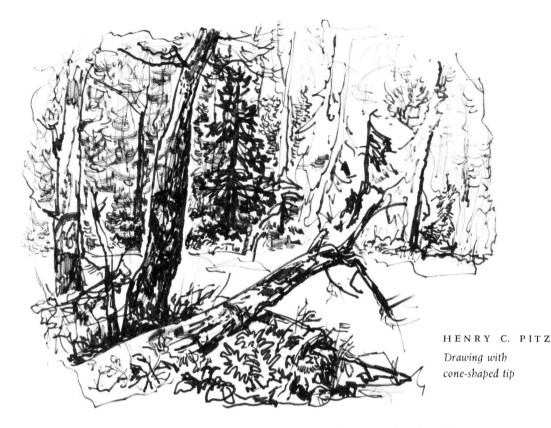

The best types of fountain felt-tip pens have a valve control. After the pen reservoir is filled from the can or bottle of ink the tip is pressed against a bit of paper and this opens the valve and the ink descends into the nib. But, if heavy pressure is continued during drawing, the ink floods the nib and makes thick blobby marks. True, sometimes this is desired but usually the best effects are obtained with a lighter pressure. The nib can be wiped on a piece of rag or blotter to take out excess ink and give a grayer line. With practice one learns when to release more ink with pressure and one can maintain an evenness of tone. If one is working for contrast of tone it is wise to use two pens, one with saturated nib for the darks and another with partially dry nib for the light grays. A considerable variety of stroke is possible with the chisel-shaped nib by rotating the pen to utilize one of the corner tips or the broad edge as desired. Each pen is supplied with a variety of nibs and these can be changed quite rapidly. In fact, with a sharp razor blade one can shape up one's own individual nibs.

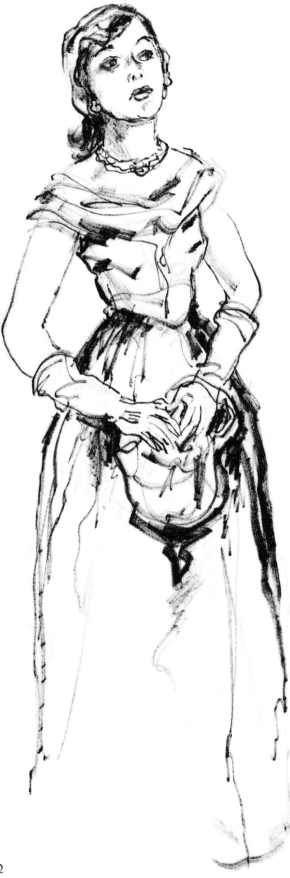

HENRY C. PITZ

The deepest darks were made with a flooded nib (by applying enough pressure to open the valve). But a flooded nib will not deliver a gray or sensitive line, so the nib must be wiped on a blotter from time to time, or better still is the use of two pens, one with saturated nib and one partly dry.

The usual ink used is an aniline dye with an oil base. This dries instantly and will not smudge but it has great penetrating power and, with thin paper stock, may penetrate several layers. For this reason soft, pulpy papers are unsatisfactory because the ink spreads. To circumvent this, the makers of the Flo-master pens have developed a water-base ink, "Brite-Line," which does not penetrate. This ink, however, must be used in a special holder designed for it.

There are three makers of felt-nib pens popular with artists, the Flo-master, the Marsh 77, and the Floquil. This last is an applicator and not equipped with a valve. These pens need not be used solely for monochromatic drawing; there is a fairly wide range of colored inks available and one color can be used over another without picking up the undercoat. Of course, a separate pen is necessary for each color.

The instrument is at its best as a sketching tool; it encourages broad, sweeping effects. It is not designed for minute detail or delicate embroidery of line but is excellent for quick, energetic statements of light and shade and strong linear renderings. One should not try to cramp it into small areas; it needs a lot of elbow room.

11: Pen and Ink with Other Media

PEN AND INK IS ONE of the most cooperative of media. It seems to have a natural affinity for all other media save perhaps oil. The modern artist has seized upon this adaptability and has put the medium through its paces, experimenting with every kind of union he has been able to imagine. Ours has become an age of mixed media and many exciting things have come out of the new combinations. But mixtures of media are not new, of course, many are very old.

HENRY C. PITZ

Drawing in ink, wash and pencil —
some areas smudged with a damp finger

BERNARD BRUSSEL-SMITH
Pen and wash drawing

One of the oldest and most widely used combinations is that of ink and wash. The masters of the Renaissance used it superbly and every age since has found it one of the most rapid and versatile ways of developing and crystallizing a pictorial conception. The ink line can quickly define the important forms and establish the skeleton of a composition. A few washes of tone or color, briskly brushed on can indicate the tonal pattern without obliterating the underlying ink structure. Many of the world's masterpieces of draughtsmanship have been accomplished by this method.

The usual procedure is for the ink drawing to precede the wash, but the reverse method is often used. Broad, sopping areas of wash may first tentatively define the form and plot the masses then, when dry, the pen or brush sharpens edges and indicates accents. The modern artist often favors this approach and draws the ink line into a moist wash producing a blurred and melting stroke. A sprightly calligraphic line, roving across masses of freshly applied washes, is one of the standard modern techniques.

BETH KRUSH

Pen and wash
Illustration for Jason and Jimmy
Harcourt, Brace & Co.

BETH KRUSH
Pen and wash
Illustration for
Gilbert Press

Of course, any or all of the pigments on the watercolor palette may be used for the washes, but for monochromatic wash the usual pigments are ivory or lamp black, sepia, payne's gray, and van dyke brown. Some prefer the unpredictable grays that come from the accumulated deposits of a dirty watercolor box lid.

Ink itself may be used for a wash by diluting with water, but it will not behave like watercolor. It dries almost immediately and shows a series of edges. The artist will not try to force the medium to cover large areas with perfectly blended color but will utilize its peculiarities to give character to his drawing. For ink wash drawings many prefer to use the ink in stick form and rub it in water to the requisite grays. This ink has a beauty not matched by the occidental commercial bottled inks. The colored inks have a definite character of their own. Successive layers of color seldom produce a muddy result; the color combinations have a richness and luminous quality unobtainable in any other medium.

The drawing of ink into wetted areas is one of the favorite tricks of the modern artist. The ink, upon contact with the water, deposits speckles of carbon in captivating patterns. These patterns are largely accidental and some artists work blindly, hoping for happy effects. Nevertheless, the process can be controlled to a considerable extent but it requires skill and practice. The difference between a merely damp area and one sopping wet is important. The ink will not shoot into a wet area but will penetrate slowly and tentatively into the damp sections. By laying down a predesigned network of damp and wet areas, the pattern can be controlled. The amount of ink used is another important factor. Also with clean brushes, blotters, and rags handy the ink areas can be modified or removed. Sometimes it is advisable to lay a series of patterns over each other by allowing the undercoat to dry before proceeding with the next. Finally, as with all techniques, the paper plays an important part. The method seems to yield better results on the finer watercolor papers and on a grained surface rather than a smooth one.

A demonstration of ink drawn into damp and flooded areas

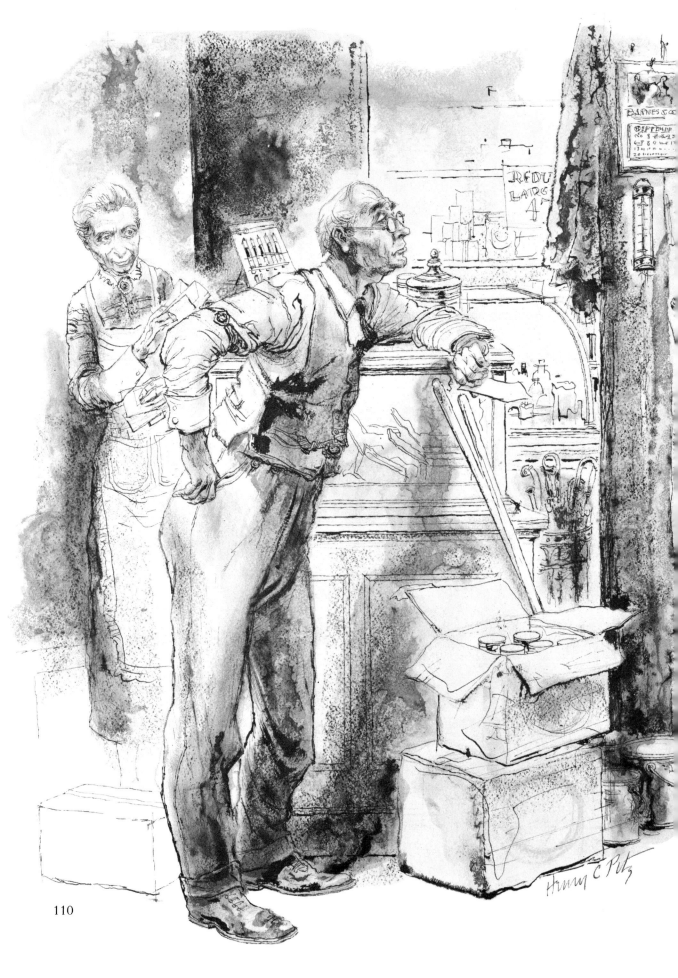

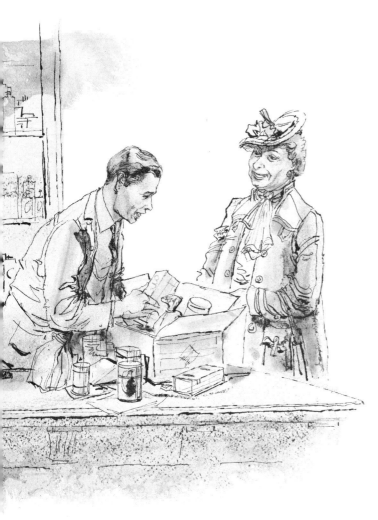

HENRY C. PITZ

Illustration for Colliers

Pen and brush drawing. Many portions were flooded and painted into with ink. Some charcoal was used (rubbed and unrubbed) to modulate some tones and watercolor was used for some of the lighter areas.

There is also more use of ink in conjunction with opaque watercolor (gouache, poster color or casein) than formerly. Any of these types of color can be used in light, translucent washes over an ink foundation, but if piled on, impasto, are very likely to crack and flake. Interesting effects are obtained by underpainting with impasto whites and glazing with colored inks. There seems to be little trouble when the inks are used thinly but dark colors piled on are prone to peel. It must be remembered that most colored inks are fugitive, the more intense colors extremely so; the browns and sepias are relatively safe.

An age-old union is that of ink with pencil and crayon. The use of the ordinary drawing pencil as a preliminary to the pen is very usual. When the drawing is to be reproduced by line cut, the pencil marks are erased (unless very light) but the pencil is often allowed to remain in drawings done for their own sake and sometimes is supplemented by additional pencil or crayon work. All grades of the usual artist's graphite pencils are used but, for those who do not like the shine and slight greasiness of the graphite lead, a favorite type is the carbon pencil such as Wolff's in degrees 3B to 2H and Hardmuth in degrees L,2 and 3. The carbon pencil makes a dark, velvety line without shine. It blends beautifully with the pen line.

A combination often used by illustrators is that of the lithographic crayon with ink. This jet black, greasy crayon when drawn with reasonable pressure on a paper with some tooth will leave a line which, under the magnifying glass, will be seen to consist of small black speckles resting on the high spots of the surface. The line has a somewhat crumbly look, which because of its difference from the pen line is one reason for its use. But the main reason is that it reproduces as readily as the pen line for line-cut purposes. The crayon comes both in pencil and stick forms. The stick form is excellent for backgrounds or large tones. The side of the crayon when swept across a textured paper can produce a highly interesting pattern of tones. Always in using a grease crayon it is necessary to remember that ink drawn over a greasy surface is not likely to adhere.

Lithographic lines and tints

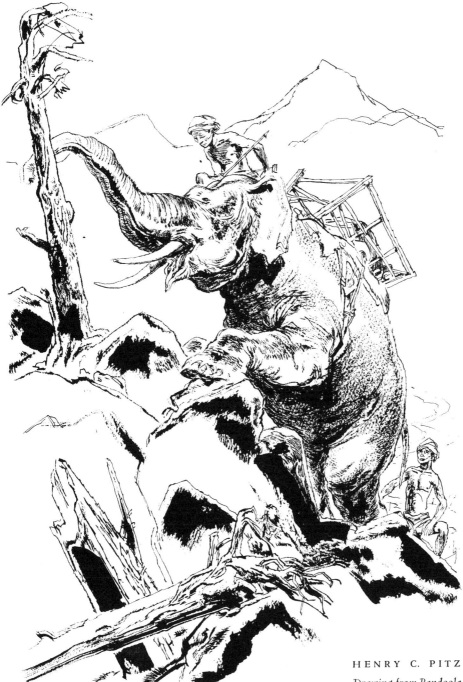

HENRY C. PITZ

Drawing from Bandoola, Rupert Hart-Davis,
London — Doubleday & Co., New York.
A pen and brush drawing.
Lithographic pencil was used, particularly on
the elephant to achieve another texture.

Charcoal and ink is not one of the usual combinations and yet it is one of the most promising and satisfactory. Like ink and wash, it offers the advantage of first concentrating upon form and composition and recording them in a permanent ink line and then playing with tonal effects freely without harming the basic drawing. It allows much freer experimentation in tone, for the charcoal masses are easily removed or modified. There is no need of waiting for washes to dry or sponging out tones that are too deep. Charcoal responds readily to a touch of the finger, the sweep of a chamois skin or the stroke of a kneaded eraser. It gives a plentitude of textures, too, using soft (vine), half-hard, hard, and compressed types in conjunction with varied surfaces of paper. In addition, charcoal combines nicely with most other types of crayon except the greasy kinds. The final ink and charcoal result should be sprayed with a fixative.

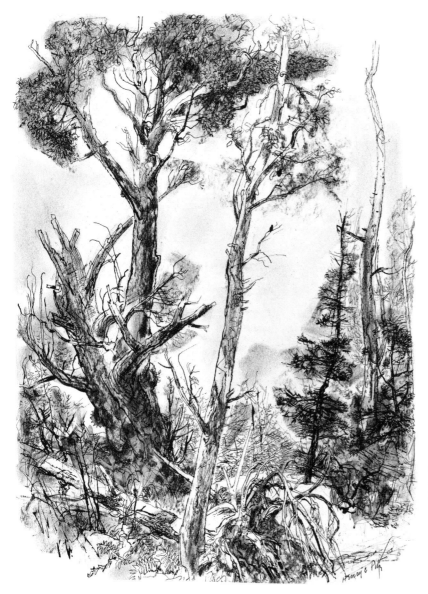

HENRY C. PITZ

Drawing in ink line, charcoal and wash from Drawing Trees, Watson-Guptill Publications.

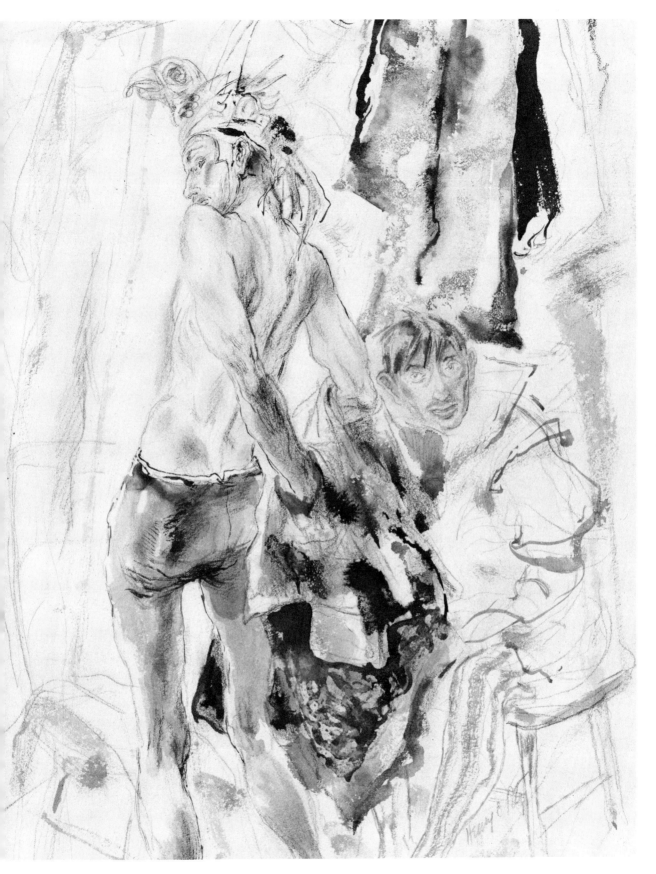

HENRY C. PITZ
Ink line, ink in water,
pencil and watercolor wash

Pastel is another good medium not frequently used with ink. It performs very much like charcoal, but it has the advantage of color. Very sprightly effects can be created by first laying down the main masses of a composition on rubbed tones of pastel, fixing these and then drawing boldly in ink line the more definite and descriptive forms. If the pastel is not piled on too heavily and is thoroughly sprayed with pastel fixative, the ink line (brush better than pen) will adhere readily.

Ink is also used sometimes to establish the basic drawing (outline or modeled) on canvas or gesso panels to be covered in part or whole by egg tempera or oil paint. The combination of ink drawing, egg tempera underpainting, and final glazing with oil is being explored by a few painters. It is an old combination which still offers wonderful opportunities.

It should be stressed that all these combinations are powerfully influenced by the kind of surface to which they are applied, paper, canvas or gesso panel. Never has the artist been offered such a variety of surfaces and while he can scarcely be expected to test all, he should certainly try all that come his way. He should not take for granted that the so-called artist papers are the only ones for him — there are many possibilities among bond, book, wrapping, writing, lining, and other papers.

Most of the combinations of media we have talked about are centuries old and have been used or neglected in turn, but our age has shown a revived interest in a multiplicity of ways and means. The present-day illustrator, for example, in his search for technical novelty has tried many methods, so much so that only a minority of illustrators now use simon-pure techniques. The "mixed media," which are now preponderant, are not merely mixtures of two media but are often of three, four, five or more in one drawing.

The modern artist finds that a lot of nonsense about "purity of medium" has been blown away. Perhaps he is still too concerned with technical oddities but, at least, the way has been cleared of ancient and intolerant taboos. He is free to choose from the greatest wealth of technical resources that has ever been available. Time will tell whether the significance of his utterance can match the richness of his pictorial language.

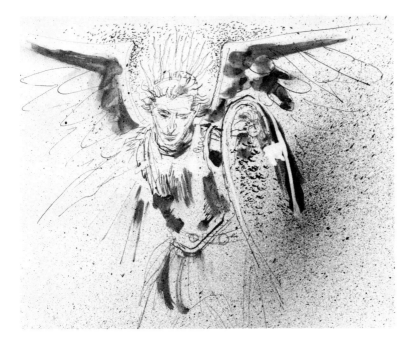

12: Special Techniques

IN RECENT YEARS there has been increased interest in special effects and manipulations which lie apart from the main path of ink technique. It is a part of the modern adventure of searching for the new and unusual and it has broadened our conceptions of ink handling. True, many of these effects are tricky and of very limited value but used knowingly they enrich our repertoire and enliven our expression.

First come two old techniques that have felt the breath of revival — stipple and spatter. The first is a laborious method and monotonous if carried to an extreme; the second permits rapid covering of a tone and both produce a soft or blended effect.

Stipple is very simple. It is nothing more than dotting the paper with pen point or brush tip. The dots may be fine or coarse and, by crowding them together or spacing them more widely apart, considerable variations are possible. Elaborately blended effects are possible with patience and painstaking care, but this very laboriousness is a handicap. An entire composition done in stipple is likely to seem tedious to the beholder, but combined with other methods of manipulation it often gives a welcome change of texture.

Stipple areas

Showing how knife edge or other instrument is drawn across ink-charged bristles and away from drawing to project speckles of ink on-to drawing

Spatter is less likely to look mechanical. It has a more spontaneous look, its effects can be achieved more quickly but they are not completely under control. Again the method is simple. The usual instrument is an old toothbrush. It may be dipped into a small saucer of ink so that the tips of the bristles are wet or the ink may be applied with a brush or stopper quill. The brush is held *bristles up*, and its end aimed at the drawing at a distance of a few inches. A knife blade or match stick is held in the other hand at right angles to the bristles and pulled back across them, *away from the drawing*. As the knife or match stick is moved across the bristles, they bend and, upon release, snap back and spray minute drops of ink on the paper. These minute ink particles have enough variation in size to build up a tone of interesting variation and texture.

There should be a good deal of experimentation on odd sheets of paper before it is attempted on a serious drawing, for only by trial and error does one learn how much ink to put on the bristles and the best distance between brush and paper.

Any ambitious job of spatter involves the use of shields or masks. Any areas not to receive the spatter have to be protected. Simple spaces may be shielded by odd bits of paper held down by any small likely objects, but intricate areas need the use of frisket paper. This is a light, transparent paper coated on one side with an adhesive. This is placed over the drawing, adhesive side down, smoothed out and pressed down over the spaces to be protected. Then the corner of a razor blade is drawn carefully around the area to be spattered, with just enough pressure to cut the frisket but not the drawing beneath. The unwanted portion is then peeled off. Before spattering it is wise to press down all edges of the remaining frisket lest they lift during spraying. Occasionally there is need for a white spatter on a dark ground (a snowstorm effect, for example). For this chinese white or poster color may be used and care must be exercised not to use too thin a mixture.

Spatter tone

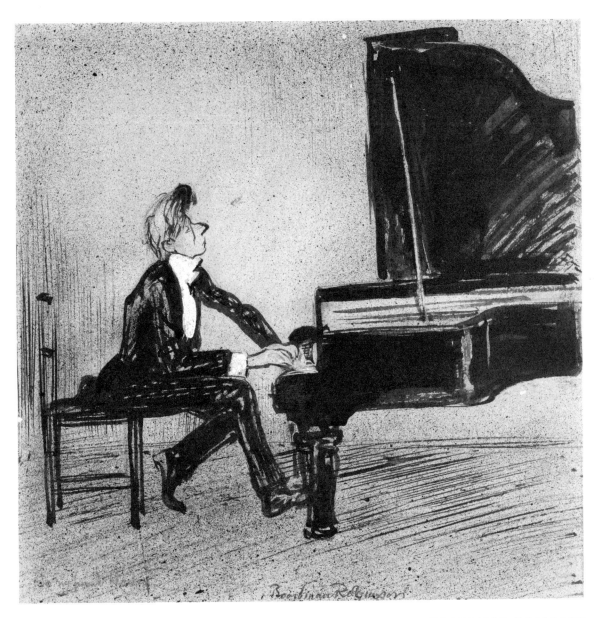

BOARDMAN ROBINSON
Spatter drawing

A variety of interesting tones can be created by making impressions of various materials onto the drawing. Wood, leather, many kinds of fabric, lace, and other materials may be brushed with ink and pressed against paper. A more satisfactory way is to glue the lighter materials to a block of wood and ink the surface lightly with a roller coated with printer's ink. This method makes a cleaner impression. Finally, one's own thumb or other fingers coated with printer's ink imprint interesting patterns.

If a drawing is made on tracing paper or light-weight bond, various *rubbed* textures can be easily created. The paper is held firmly over some suitable texture, a copper screen or linen book cover for instance, and the paper rubbed with a lithographic pencil. A firm surface must be used but the variety of possible textures is very great — brick, wood, various kinds of cloth, leather, and chased metal are just a few.

A trick method that has some mild possibilities is the utilization of the ink resistant powers of wax. A sheet of textured paper may be rubbed with a candle end or a white wax crayon and then a drawing made upon this surface with a pen or brush, but preferably a brush. The waxed areas resist the ink and often give a pleasantly irregular line or tone. A drawing may have to be worked over a number of times before a sufficient amount of ink adheres. The wax crayon may also be used to draw an arabesque pattern on paper and ink washed over it will reveal the pattern in white irregular tracery.

WOOL

LINEN

LACE

THUMB

Printed textures

Rubbed textures on tracing paper

A method of rather greater possibilities is the *resist* method. White poster paint is used to paint in an image on white paper. Only the areas and lines that are to remain white are painted, so the artist must be an excellent visualizer. When dry the drawing is brushed all over with black, gray or colored ink. When the ink is dry the paint (which has protected the paper from the ink) is washed off and the image appears. There are a great many possibilities in this method because there can be a number of stages of painting in poster white and washing over with various toned or colored inks. Also with experience one learns that thin painting permits some of the ink to penetrate, so that considerable modeling and blending is possible.

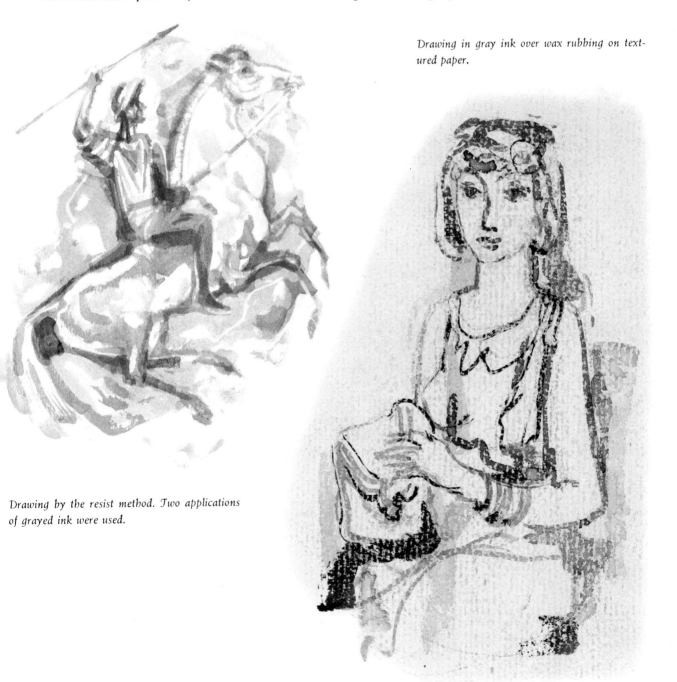

Drawing in gray ink over wax rubbing on textured paper.

Drawing by the resist method. Two applications of grayed ink were used.

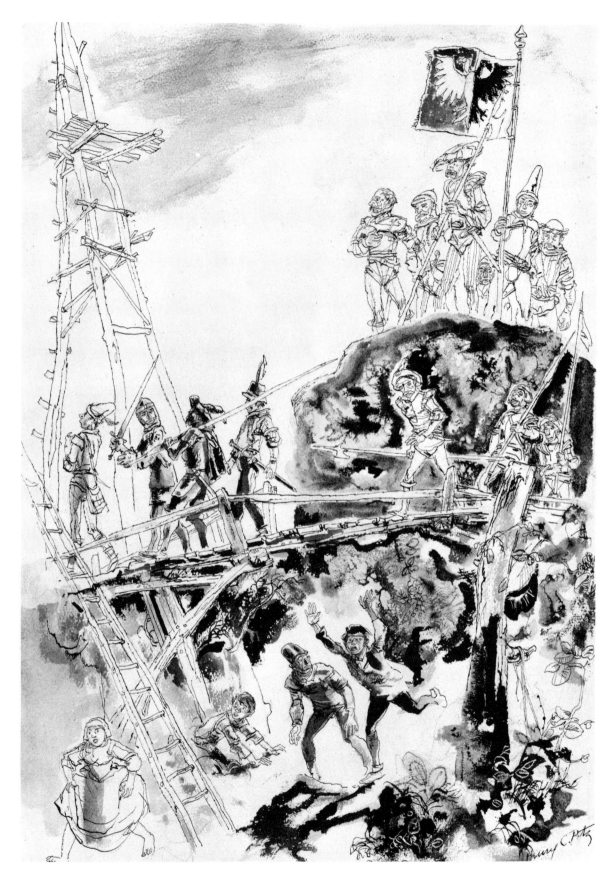

HENRY C. PITZ
Pen line and ink in water

The practice of drawing with pen or brush on a wet surface is one of the more popular modern methods. This is a semi-accidental method, only subject to limited control. It has the fascination of the unexpected for, as the ink touches the wet paper, it coils and spreads and deposits a filigree of tiny black crystal-like forms. The degree of spreading can be somewhat controlled by the amount of water placed on the paper — the more water the greater the spread. The direction of the spread can be influenced, too, by painting in water whatever pattern one wishes the ink to follow. For most effects it is preferable to use only a small amount of ink in the pen or brush.

All of these special effects have interest but only limited value. Mostly they are of greater value as adjuncts to the more usual and versatile methods. Special and tricky methods always have a fascination for those seeking a magic answer. The magic answer is not in technique.

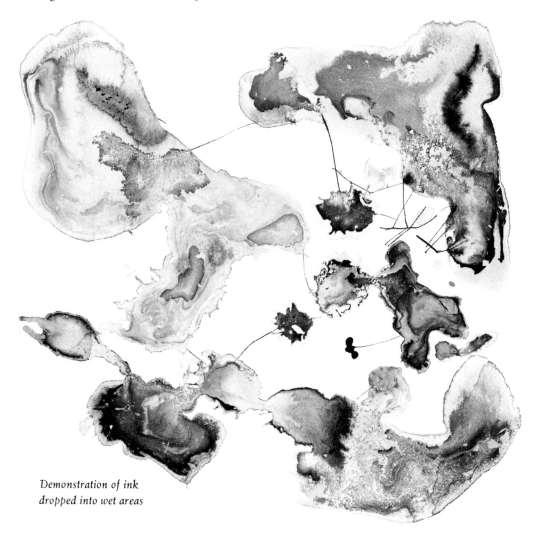

Demonstration of ink
dropped into wet areas

WALTER KUMME
Scratchboard drawing

13; *Special Surfaces*

THERE IS A WHOLE SERIES of methods made possible for the ink artist by drawing boards and papers with specially prepared surfaces. Most of these are used by the commercial artist, but they should be of interest to all draughtsmen.

One of the most important of these materials is scratchboard. This is a drawing board coated with a smooth chalky surface. This surface is very smooth and firm and takes pencil and ink readily. Both pen and brush may be used on it, but the pen must be used with reasonable discretion; a slashing attack may cut the surface since it has been especially prepared for incising by the stroke of a metal point. This ability to be readily incised permits the technique of the *white* line, comparable to that obtained by wood engraving. In fact, the artist is able to produce in scratchboard all of the effects of wood engraving with much less effort and without needing the very special skill of the engraver.

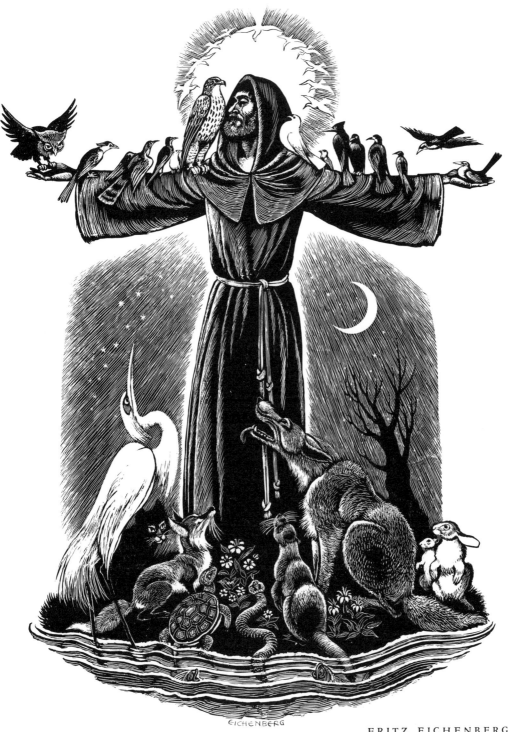

FRITZ EICHENBERG
Scratchboard drawing

Scratchboard patterns

The *white* line is easy to obtain. A tone of black ink is brushed over the board and into this white lines, dots or other calligraphy is easily scratched with a suitable tool. These lines can be made with considerable freedom for a sharp metal point cuts the chalky coating with little resistance. Very little pressure is necessary and deep penetration is usually a mistake. When the surface is lightly incised, corrections can be made easily, by re-inking the scratched area and recutting a second time.

It is possible to use a variety of cutting tools — razor-blade corners and edges, etching needles, dentist's probes, penknife points, X-Acto knives and, what is perhaps the best all-around tool, the triangular-shaped steel eraser or scratch knife. This looks like a pen-nib, fits into a pen holder and is very inexpensive. Wood engravers tools may also be used — the most useful being the multiple graver which makes a number of parallel lines at one stroke. Before incising, the ink areas should be thoroughly dry or else the tool will gouge out ragged lines. Very damp weather is an enemy; sometimes the board must be dried out by artificial heat before cutting.

The approach to scratchboard rendering varies; some black-in the whole picture area, then draw in the major forms in white pastel or crayon, or trace off a master drawing on tracing paper through a sheet of *white* transfer paper. This method is suitable only if the whole picture is to be quite dark in tone. It isn't feasible to black-in largish areas that are to be white or very light in the finished picture.

The more usual procedure is to black-in areas one by one and model each in white line before passing on to the next. There is danger, in this method, of the picture developing into a series of badly related areas unless the artist has a master drawing before him as a guide or is experienced at visualization and control. One need not rely entirely on the white-line technique in scratchboard; the normal black line is often combined with it. The whole handling has been too closely tied to the wood engraving tradition and there is room for experimentation and combination of it with some of the more bizarre effects of pen and ink.

Good scratchboards in this country are made by the Charles J. Ross Company and Artone. There is also a black-surfaced scratchboard sold.

126

In addition to the smooth-surfaced type of scratchboard the Ross Company makes a wide variety in which the surfaces are modeled into minute patterns of fine dots, grains, and other forms. Lithographic crayon rubbed over the surface or ink brushed lightly, touches the raised portions and reveals the pattern in black. The pattern is revealed in reverse if the surface is entirely blacked and then scraped lightly with a razor blade, exposing the high parts of the pattern in white.

Another type of Ross board carries imprinted patterns such as dots, grills, grains, and herringbones. These, too, may be scraped, incised or blacked out. These ready imprinted patterns are often useful in small vignette sketches but on a large scale may seem monotonous and contrived.

Grumbacher makes a line of "Repro" boards and also a Coquille board. These, too, are white boards impressed with various finishes such as rough and fine stipple, bead, and various simulated half tones. These patterns are revealed by drawing with a lithographic pencil or Grumbacher Cartoonist pencil. This series is mostly used to obtain halftone effects with a drawing that will reproduce in line. These sheets are not made for scraping or incising.

Drawing on Grumbacher "Repro" board — 158 — 12

158-4 **Rough Stipple**	**158-6** **Bead**	**158-8** **Fine Half-Tone**	**158-10** **Coarse Half-Tone**	**158-12** **Dot**

Various surfaces of Grumbacher's "Repro" board

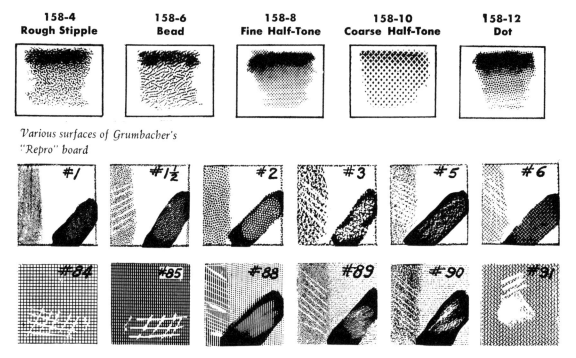

Selection of Ross drawing board surfaces

127

A very interesting series of boards is made by Craftint, in which tones are made visible by means of a developer. There are two types, Singletone and Doubletone. As the name suggests the Singletone board contains a single concealed pattern. A drawing is made on it in the usual way with waterproof india ink. Wherever tone is desired, a special developer fluid is applied with a clean brush. The tone appears and darkens quickly. At the right density a blotter is applied to halt development. The procedure with Doubletone is much the same. It contains two tones, one light and one dark. The dark group are brought out by applying one developer and, when this is satisfactory, the brush is cleaned and the second developer is used to reveal the light gray. The resulting drawing is in black, white, light gray, and dark gray.

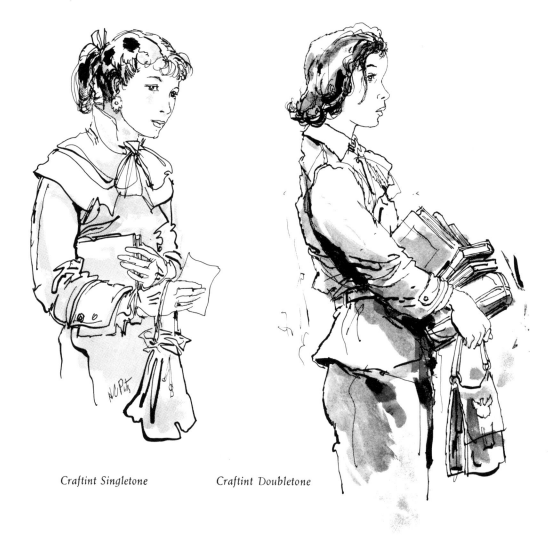

Craftint Singletone *Craftint Doubletone*

EDWARD BAWDEN
Illustration from
London Is London
Chatto & Windus

14: Ink Techniques for the Illustrator

ALL OF THE INK TECHNIQUES can be and have been used by the illustrator. In fact, they are among the most widely used of the illustrative media. But most of the time the illustrator uses ink in a special way. He usually selects it because the mechanical limitations of a job dictate that his drawing must be reproducible by line engraving. The line engraving is, for most purposes, the cheapest method of reproduction and, if well made and well printed, produces a facsimile of the original drawing. Also, the impression from a line engraving is akin to that of type, so that an affinity is present between the type page and the printed illustration.

The illustrator who must work for line-engraving requirements should know something of the process. It is a complex process and many hands take part in it but briefly this is how line-engravings (also called plates or cuts) are made. The ink drawing is photographed onto a glass plate, which is developed and the film stripped from the glass. The film is then brought in contact with a sensitized metal plate — zinc or sometimes copper. The picture is transferred to the sensitized metal by exposure to light, the image developed, and the plate washed. On the plate is now a film tracery which is a duplicate of the black lines of the drawing — the other portions of the plate are clear. The plate is placed in a bath of acid and the portions unprotected by film are "bitten," or eaten away by the acid. When the acid has "bitten" deeply enough the plate is cleaned and nailed to a wooden block, type-high, and is ready for the printing press.

The completed line engraving, if examined, will be seen to be pitted with depressions in the metal. These depressions will not receive ink and will be the white paper spaces in the reproduction. The upper surface of the metal will repeat in reverse the black line tracery of the drawing. This upper surface will receive ink from the roller and transmit it to the paper — a black line replica of the drawing.

This is a condensed description of the process, but it is not necessary for the artist to know every detail or some of the minor stages. But no description can completely visualize the process; the interested artist should try to arrange to see a photoengraving plant at work.

The principal concerns that the illustrator has in preparing his drawing for this type of reproduction are first, to keep every line of his drawing clear, black, and sharp; second, to avoid over-fussiness of handling which is likely to result in clotting and filling up of the darks during printing; and third, to make certain that when his drawing is reduced to plate size it will not lose too much of its character or definition.

To provide the maximum of contrast for the engraver's photographer the drawing should be on clean, white paper and a truly black ink used (Higgins Super Black, Craftint "66" Jet Black, and Artone Extra Dense are excellent). It is easy to allow the ink in pen or brush to dwindle until the strokes become gray. Gray lines often do not reproduce.

AUSTIN BRIGGS

Illustration for Readers Digest Condensed Books. This drawing was made for line reproduction and comes out splendidly but is actually drawn in crayon. This gives the line its slightly crumbly texture. But to ensure reproduction the artist must not use his crayon or carbon pencil in a tentative way — every line must be dark and positive.

The illustrator should also look ahead to the kind of paper upon which his drawing will be reproduced and adjust his technique accordingly. A smooth paper of superior quality will permit of a fine line and delicate drawing; a coarse, blottery paper requires a heavy and bold technique. Coated papers give clean, sharp impressions; rough stocks tend to print with blurred, broken, and spread lines.

When an ink drawing is completed for reproduction, the thumb marks and pencil lines should be erased. Light pencil lines will not appear in the printing plate but dark ones may. A soft eraser such as Artgum, or Grumbacher's or Weber's kneaded erasers should be used lightly, for heavy scrubbing will gray the ink lines and possibly prevent them from reproducing clearly.

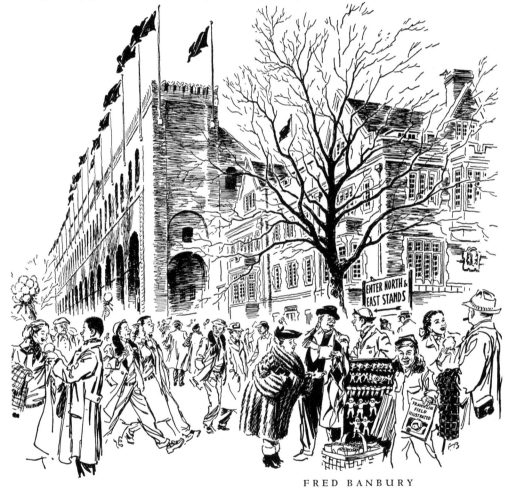

FRED BANBURY

Drawing for First Pennsylvania Company

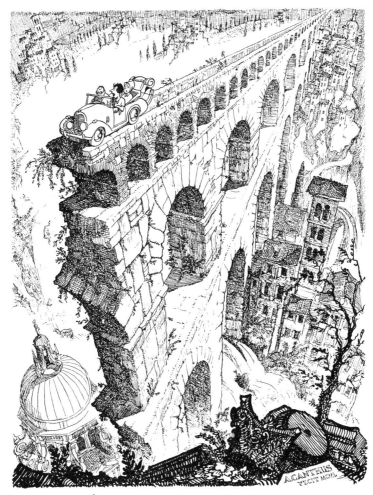

FRANK HOAR (ACANTHUS)

Drawing from Punch

The best reproduction comes from ink drawing that is clean and fairly open; overworked and tortured areas often clog up and print black. Too much filigreed detail is likely to break down in reproduction. The degree of reduction is also a factor in good reproduction. Most illustrations are made larger than they are to be reproduced, often from one and a half to two times larger, but the degree of enlargement is usually determined by the inclination of the artist. But the greater the degree of reduction necessary for reproduction, the more open and simplified the ink tracery should be; the more delicate and finely detailed a drawing is, the less successfully will it stand considerable reduction.

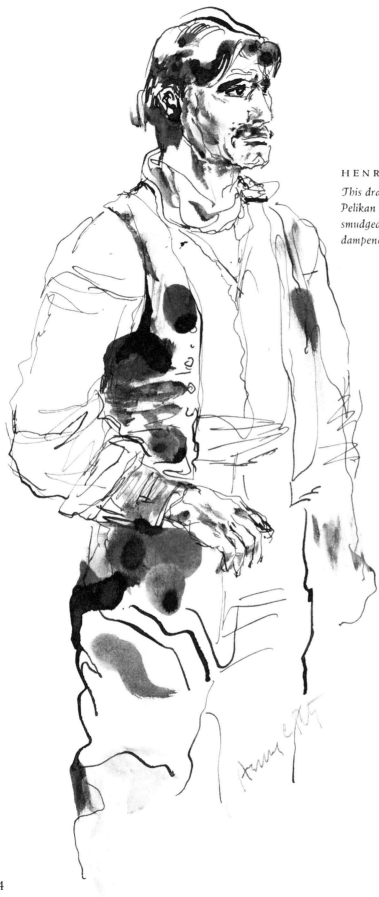

HENRY C. PITZ

This drawing was made with a fountain pen using Pelikan Fount India ink. Some of the lines were smudged while wet, others were rubbed with a dampened finger when dry.

The field for the illustrator who uses the ink techniques is large and expanding. Line reproduction plays a major part in the illustration of books, particularly children's books. It is widely used in many kinds of advertising, particularly for folders, fillers, cards, booklets, and all kind of direct mail publicity and to some extent in magazine advertising. The large national magazines use it sparingly but it appears abundantly in the smaller magazines and trade journals. It is common in what is now the limited field of newspaper illustration. There it is found not only in the advertising spaces, but in the cartoons, comic strips, sports drawings, and spot drawings in the Sunday feature sections. During the past half century the art of pen, brush, and ink has been kept flourishing largely because the publishers have demanded that many of their artists work in that medium. That demand is still strong and the future looks bright for the artist who draws in ink line.

HENRY C. PITZ
Line drawing for 20,000 Leagues Under the Sea — Doubleday & Co.

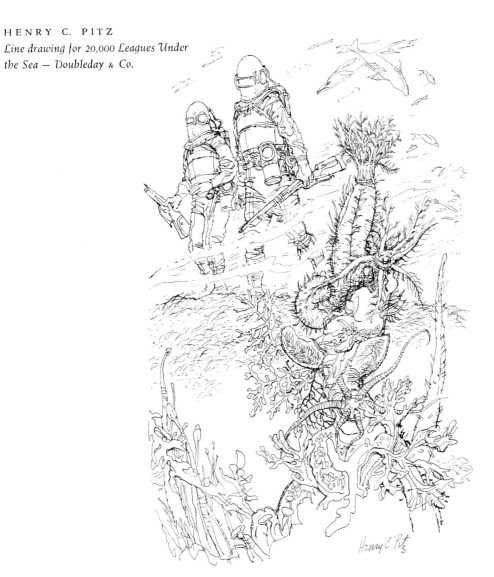

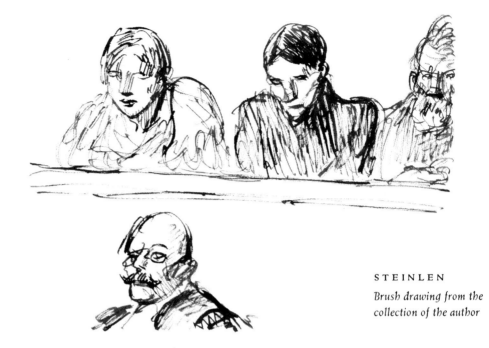

15: *Beyond Technique*

WE HAVE TALKED A GREAT DEAL about technique, for that is the task we have assigned to ourselves, but our final words should carry us beyond it. Technique is of great importance but not of first importance. It is a means to an end, it should not be an end in itself. It is a language over which we acquire command, not for the sake of the language itself but for what we can say with it.

What we say with it will rise up out of our life experience, for experience is the great reservoir of the material of art. Experience, by and large, is directionless and without form, but it is the province of the artist to search it for significance and shape his findings into the forms of art. He discovers an order in the confusion and presents us with revelations of that order.

It is natural for the young, driven artist to focus his energies upon the mastery of technique. This may be an all consuming drive, temporarily for some, permanently for others. But the gifted and determined artist reaches a point where technical struggles no longer absorb his major energies and he is free to meditate upon *purpose*. He may look out into the baffling, headlong world for themes that will move him to speak in picture terms or he may peer into his own nature for clues, signs, and revelations. The inner chambers must quicken to some stimuli of experience; there must be a felt *aliveness* that cries to be communicated in graphic terms.

CHARLES KEENE

A free pen sketch in brown ink. Keene usually made numerous sketches for each illustration and selected the best to be turned over to the wood engraver for reproduction. From the collection of the author.

No one but the artist himself can know what touches off that aliveness. It will be foreordained by his nature. It may spring from great or little things. It may be a concern with the incidental or the transcendental. But it must be his own discovery and flow with the tides of his nature. His gift may lie with the little, touching gestures of the human tribe, in a deep, primitive awareness of the sockets of ridge and plain, in a love for the minute green filigree that hugs the earth's skin or an epic grasp of the meaning of an age. The artist cannot make an arbitrary choice; he must follow the behest of his gifts. But all this does not happen overnight; it must be grown into. The young artist will have time for that, but he must raise his eyes from his work at times and take long looks ahead.

STEINLEN

*Sketchbook drawing from
the collection of the author*

Meanwhile, he is beleaguered by the problems of day to day. He has good days when the thing he calls inspiration swings him along. On these days he knows that there is no separation between technique and content, the two are one, merged in happy conjunction. The teeming images of the mind press down the arm to the skilled fingers and seem to leap into graphic shapes on the paper in one tidal flow. But there are other days when the skull seems resonant with emptiness and the fingers trace limp and meaningless shapes. He learns that no artist can command constant inspiration; it is a human limitation.

Knowing this, many artists are inclined to play a waiting game. They wait, listening for the whisper of authentic inspiration. But this policy has its dangers. It plays to his weakness. As the years go on, the waiting intervals become longer, become a settled habit; the moments of inspiration become shorter and more infrequent.

The deeply creative periods are surrounded with mystery but they seem susceptible to nourishment. Those who expectantly make demands upon them seem to have the better of it. When an artist enters his studio and picks up his familiar tools he tends to awaken the creative impulses. Facing his paper with depleted mind, but forcing his hand to begin the familiar motions often awakens the slumbering will and the mind catches fire.

There is no formula that will cure sluggish creation, of course, but the artist who persists in his pictorial intentions in spite of lassitude and other antagonistic factors is more likely to have prolonged creative periods. So the young artist should not readily capitulate merely because the inner weather is less than ideal.

There is often a tendency to think of inspiration in terms of frenzy. But there is both warmth and coolness in the molding of a picture; warm hours of dream and vision, of incubation and the excitement of images shifting, sorting, and finding their appointed places; cool moments of appraisal, judicial evaluation and clear-headed planning.

As picture follows picture, the artist expects to grow and usually does, but he should not be disappointed if the pattern is not steady and orderly, each step automatically ahead of the previous one in a constant rise of power. The artist's progress has a tendency to be uneven or even erratic. There is almost a certainty

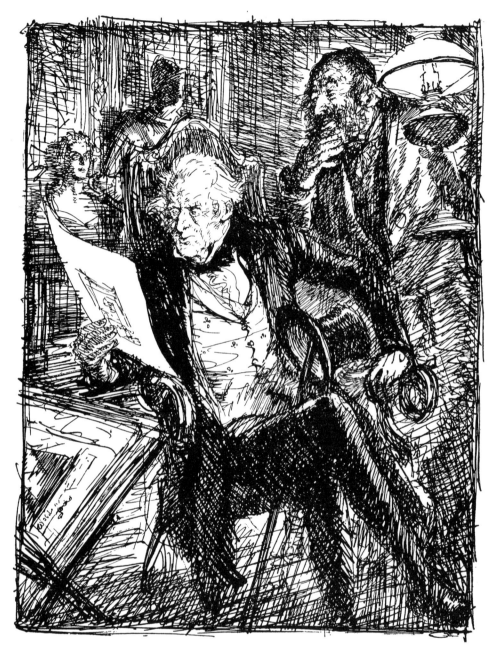

EDMUND SULLIVAN
*Preliminary sketch
for an advertisement*

of sudden advances, unexplained retrogressions, detours, and fruitless explorations of blind alleys. But all things good and bad shape the artist. Advances come sometimes stealthily, sometimes spectacularly and then are prone to level off for a while. There are certain to be plateaus of attainment that after a while fret the artist with their monotony.

That fretfulness is healthy, for it may induce him to cast about for another stimulant. Too intensive preoccupation with one medium, for instance, may lead to staleness. The cure may lie in the challenge of mastering a new one and this may well reanimate the old. Or there can be a change in scale of working or a search for new subject matter. The artist is conscious that he is moving in a rut and must cast about for drastic means to pull himself out of it.

He becomes aware of the paradox of technical dexterity. He has spent years teaching his hand the cunning to translate the images of his imagination, only to find that the hard won competence has encouraged complacency. The competence has become a system and the technique is making the pictures.

So the artist must lead a life of vigilance. To become expert but not to become the victim of that expertness. To keep fresh and aware and constantly open to astonishment. Probably an impossible task, but the artist is committed to the impossible.

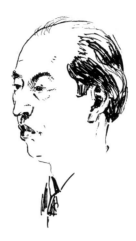

A list of Selected Books

The literature of the ink media is not extensive. In the past, three books might be mentioned as of major importance.

PEN DRAWING AND PEN DRAUGHTSMEN, by Joseph Pennell; New York and London, The Macmillan Co., 1894.

This monumental volume was the first attempt to survey the world field and assemble hundreds of well-reproduced pen drawings from many countries. It is opinionated and cantankerous but always alive. It is out of print but worthwhile searching for.

PEN DRAWING AND PEN DRAUGHTSMEN, by Joseph Pennell; New York, The Macmillan Co., and London, T. Fisher Unwin Ltd., 1920.

This is the same title, but so revised in text and pictures as to constitute practically a new book.

PEN DRAWING, by Charles D. Maginnis, Boston, Bates and Guild Co., 1921.

A small manual packed with knowing information. One of the best treatises on pen drawing ever written. Out of print and difficult to come by except in large libraries.

DRAWING WITH PEN AND INK, by Arthur L. Guptill; New York, Reinhold Publishing Corp., 1928.

A large book, lavishly illustrated. All phases of pen drawing are covered with particularly fine material on architectural rendering.

Manuals devoted to the ink techniques are few in number but there are many books containing fine examples of ink drawing or important information about it. All of the books mentioned would be worthwhile additions to the student's library but some are not readily available and some are expensive. But any student resident in a large city is likely to find many or all of them available in the art sections of the city's main library.

TECHNIQUES, Brooklyn, N. Y., Higgins Ink Company, 1948.

The fifth edition of this 48-page booklet is available from the Higgins Ink Co., 271 Ninth St., Brooklyn, N. Y., for $1.25. It is inexpensive enough to be within reach of everyone and is crammed with excellent pictures and information.

PELIKAN DRAWING INKS, Hannover, Gunther Wagner, Pelikan Werke.

This booklet contains a number of interesting articles and illustrations of ink techniques. A limited number are available free from John Henschel & Co., 105 East 29th St., New York 16, N. Y.

PEN AND INK DRAWING, by Frank Hoar, London and New York, The Studio Publications, 1955.

A recent British publication available in this country. It is well illustrated, particularly rich in fine drawings by the older masters. A valuable section is devoted to the work of contemporary artists who comment on their own methods.

LINE DRAWING FOR REPRODUCTION, by "Ashley," New York and London, The Studio Publications, 1938.

A manual for the line illustrator written from the British point of view.

GRAPHIC DESIGN, by Leon Friend and Joseph Hefter; New York, Whittlesey House, 1936.

A large, richly illustrated book covering all the graphic media, with a substantial portion devoted to the ink techniques. Out of print but a valuable addition to any artist's library.

500 YEARS OF ART IN ILLUSTRATION, by Howard Simon; New York, World Publishing Co., 1945.

Over 450 pages of illustrations, mostly in line, of important artists from the middle ages to the present, with a short running commentary.

ADVENTURES IN MONOCHROME, by James Laver; London and New York, The Studio Publications.

An exciting anthology of pictures, many in the ink techniques.

THE PRACTICE OF ILLUSTRATION, by Henry C. Pitz; New York, Watson-Guptill Publications, 1947.

For the artist who wishes to utilize the ink techniques in the field of illustration. Reproduction and other professional problems discussed.

DRAWING TREES, by Henry C. Pitz; New York, Watson-Guptill Publications, 1956.

As the title suggests, devoted only to the specialized subject of trees. Discusses many techniques, including those of pen, brush, and ink.

A COMPLETE GUIDE TO DRAWING, CARTOONING AND PAINTING, edited by Gene Byrnes; text by A. Thornton Bishop; New York, Simon and Schuster, 1947.

A kind of encyclopedia, portions devoted to the ink techniques.

SCRATCHBOARD DRAWING, by Merritt Cutler; New York, Watson-Guptill Publications, 1950.

As its title suggests, a manual concerned entirely with the technique of scratchboard.

SKETCHING IN PEN AND INK, by Donald Maxwell; London, Pitman & Sons, 1936.

LANDSCAPE DRAWING IN PEN AND INK, by J. Geoffrey Garratt; London and New York, Pitman Publishing Corporation, 1950.

Two British books of great interest. The Garratt book has rather more specific information, the Maxwell is more chatty.

THE MAGIC OF LINE, by Percy V. Bradshaw, London and New York, Studio Publications, 1949.

A book richly illustrated with all types of line drawing (including many ink techniques) from the early cave drawings to Degas. A stimulating pageant of man's linear expression, supported by an enlightening text.

PEN-AND-INK DRAWING: ART AND TECHNIQUE, by Frederic Taubes; New York, Watson-Guptill Publications, 1956.

An exploration of the materials and methods of pen-and-ink drawing with definitive illustrations by the author.